To my son Christian, art of my art...

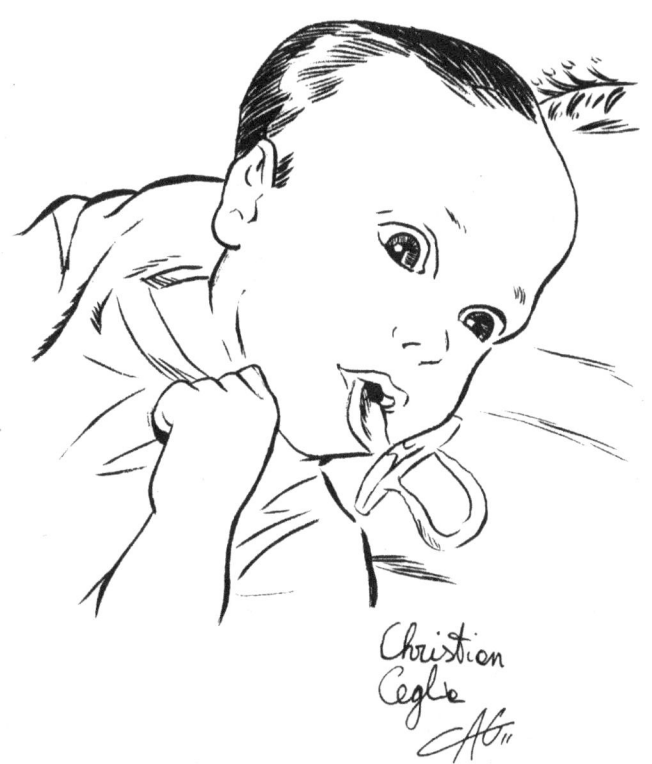

Artwork by
A. G. Ceglia

Written by
C. Sesselego

Designed by
C. Sesselego, E. Civiletti

Tacticles the Art of Geranto Touch to Believe! © 2013 Blue Monkey Studio.

Blue Monkey Studio di Sesselego, Livi, Civiletti
Via XX Settembre 23/b – 16121 Genova IT
www.bemystudio.com

All Bonelli characters ™ and © 2013 Sergio Bonelli Editore
John Doe, Trapassati Inc and other Eura characters and likeliness ™ and © 2013 Editoriale Aurea S.r.l.
Carson of Venus and all related characters are ™ 2013 Edgar Rice Burroughs, Inc
Conan and all related characters ® and © 2013 Conan Properties international, LLC
John Carter Warlord of Mars, Dejah Thoris, Barsoom and all related characters ™ 2013 Edgar Rice Burroughs, Inc
Red Sonja ® and © 2013 Red Sonja llc
Tarzan ® and all related characters ™ 2013 Edgar Rice Burroughs, Inc
All other chracters TM and © 2013 by their respective copyright holders

Sullivan, TNTeens Chronicles characters, images and likeliness ™ and © of Blue Monkey Studio.
Artwork in the Golden Age section of this book © Blue Monkey Studio
All remaining artwork and previously unpublished art © 2013 A. Gerardo Ceglia

This is an academic work. These and other ©, ® and ™ appear as historic examples of A. Gerardo Ceglia artwork for scholarly purposes. All rights reserved. Blue Monkey Studio makes no representation of any rights to said ©, ® and ™.

No part of this book may be used or reproduced in any manner whatsoever without written permission except in the case of brief quotations embodied in critical articles and reviews

ISBN: 978-1-365-09861-1

Tacticles

The art of Geranto, Touch to Believe!

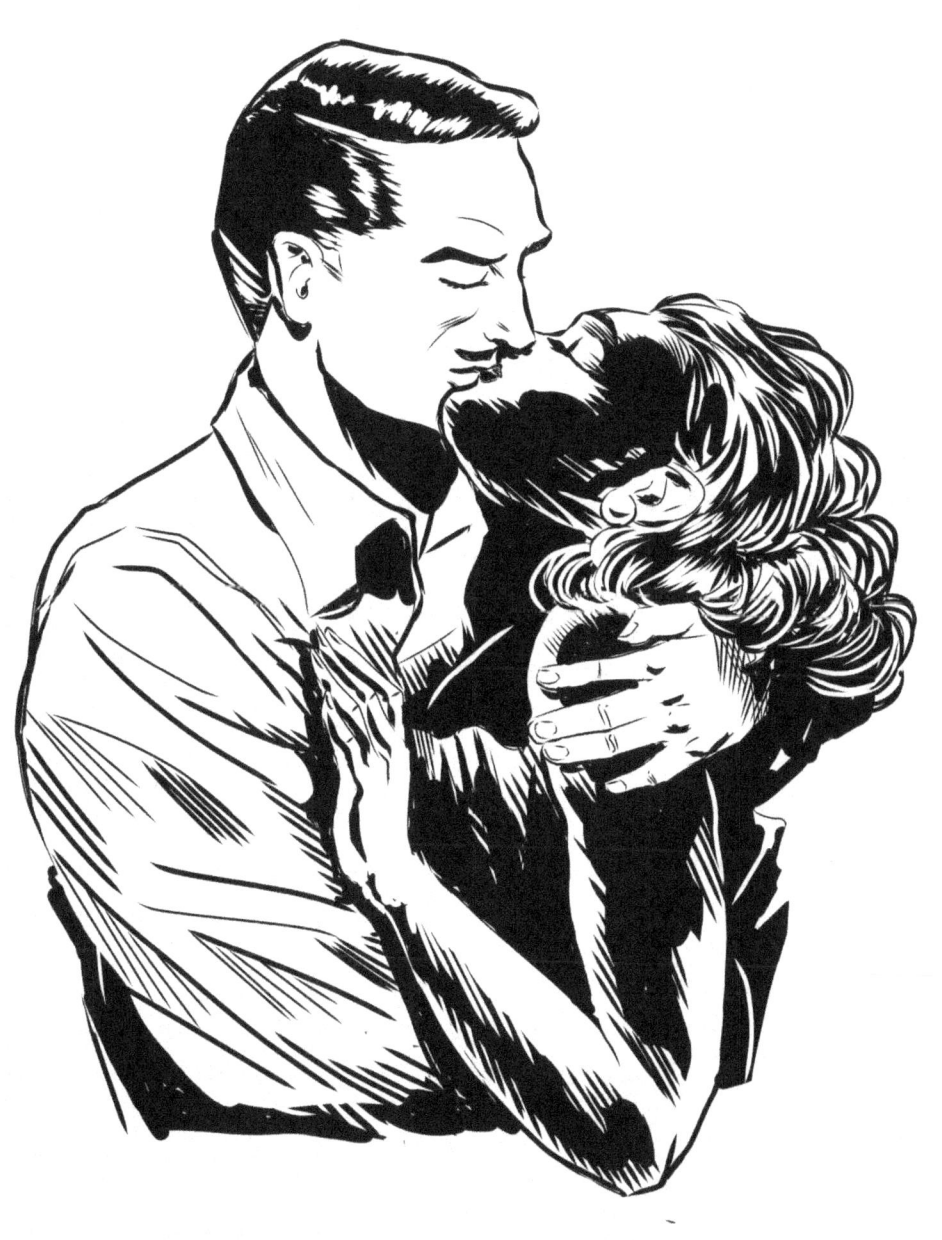

Foreword

Geranto is probably one of the shyest persons I have ever met.

When you talk to him, you have the impression that he will always refrain to utter his opinion, not because he hasn't got one, but because he doesn't want to hurt the feelings of his interlocutor. He is also your friendly neighborhood (pun intended) family man, caring with his wife and incredibly gentle with his children.

If you want to spend some quite time enjoying a relaxed conversation, he is the right person for you.

Things changes when he takes out his pencil and brush from of his drawer. Those are the artifacts he pours his inner power into.

The shy man disappears as soon as strong lines run around the paper. Beautiful women with bodies you can almost interact with come out of nothing, only to be perfected by powerful strokes of ink. Muscles are built on men, matching strong facial features and glances that can make you shake.

Aliens, pirates, cowboys, gunslingers and detectives are like real-life people living in a world like our own, only black & white.

Geranto has never visited New York, the Nevada Desert or Mars, yet when these places are outlined in panels they are not just done right, they have the right feeling.

If depicted, violence or sex are like a slap on the face, but not because they are too explicitly drawn, because they are emotively captivating.

Little room is left to run away from the stories he draws and once you to start looking you don't want to leave, until you reach the end.

You don't ready the tale, you touch it, both mentally and physically and the story touches you back, like a shadow on your own shadow.

Power is not the only things there is in Geranto's art. The feeling of retroism running through his art is the perfect touch that softens the edges, making things nostalgic, but no less believable. Some of it is taken from Italian B-movies, some from Silver Age American comics and some from Italian black & white "fumetti", then rolled together and spread on each illustration.

You still don't believe me?

Come and touch it!

Corrado Sesselego – BMS

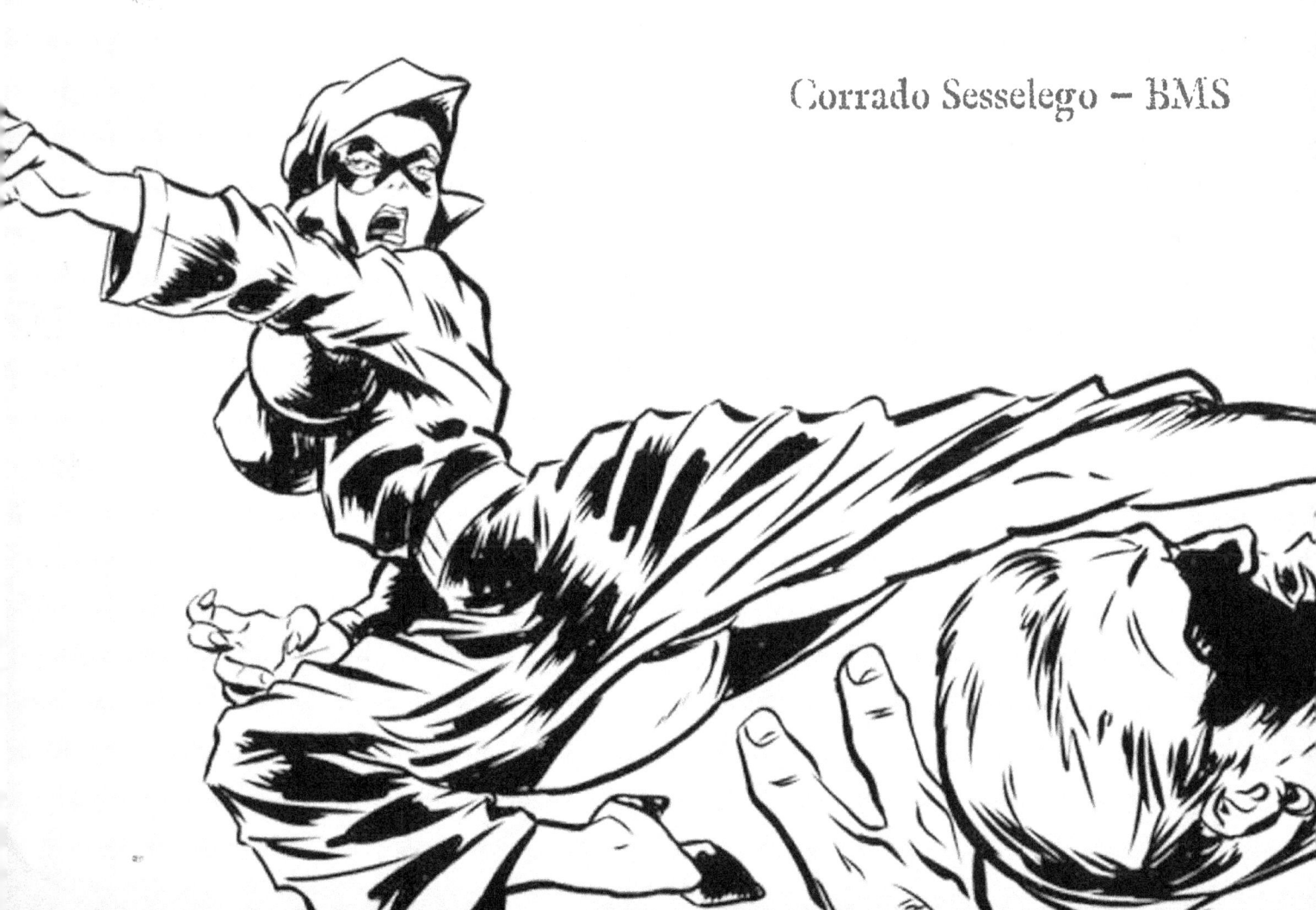

Sullivan

A mystery story taking place in the present-day UK.

The main character, Sullivan, is a young journalist exploring the secretive world of the Powered, people with an evolved brain.

Danger, action and sex are rolled together just before you are forced to take a plunge in the ocean of madness...

The story is much more alike to what I am used to read...

An Italian "fumetto" with a lot of talking and less action than a traditional American comics.

As a staunch fan of Zagor (Sergio Bonelli's western two-fisted vigilante), I was very enthusiastic to step into a known territory...

...or so I believed...

I had much room to develop the characters and places in my own way, but there were a lot of small things to pay attention to...

The songs that are mentioned in the plot drove me crazy... Where did the writer find them?

London areas were described in a endless number of details, forcing me to collect thousands of photos to get all the angles...

...and so on...

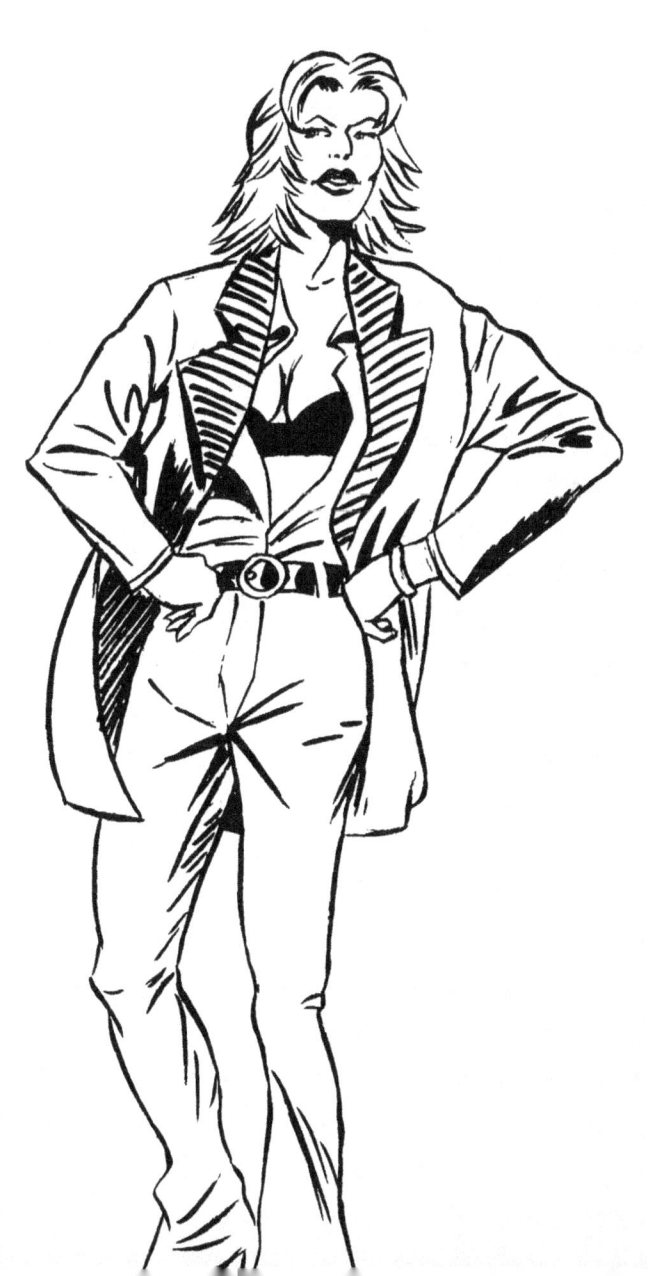

Sullivan

This is what I got to draw...

...a beautiful blonde, totally unaware of her sex appeal...

...uncaring about the way she looks, with a taste for comfortable clothes and nerdy glasses...

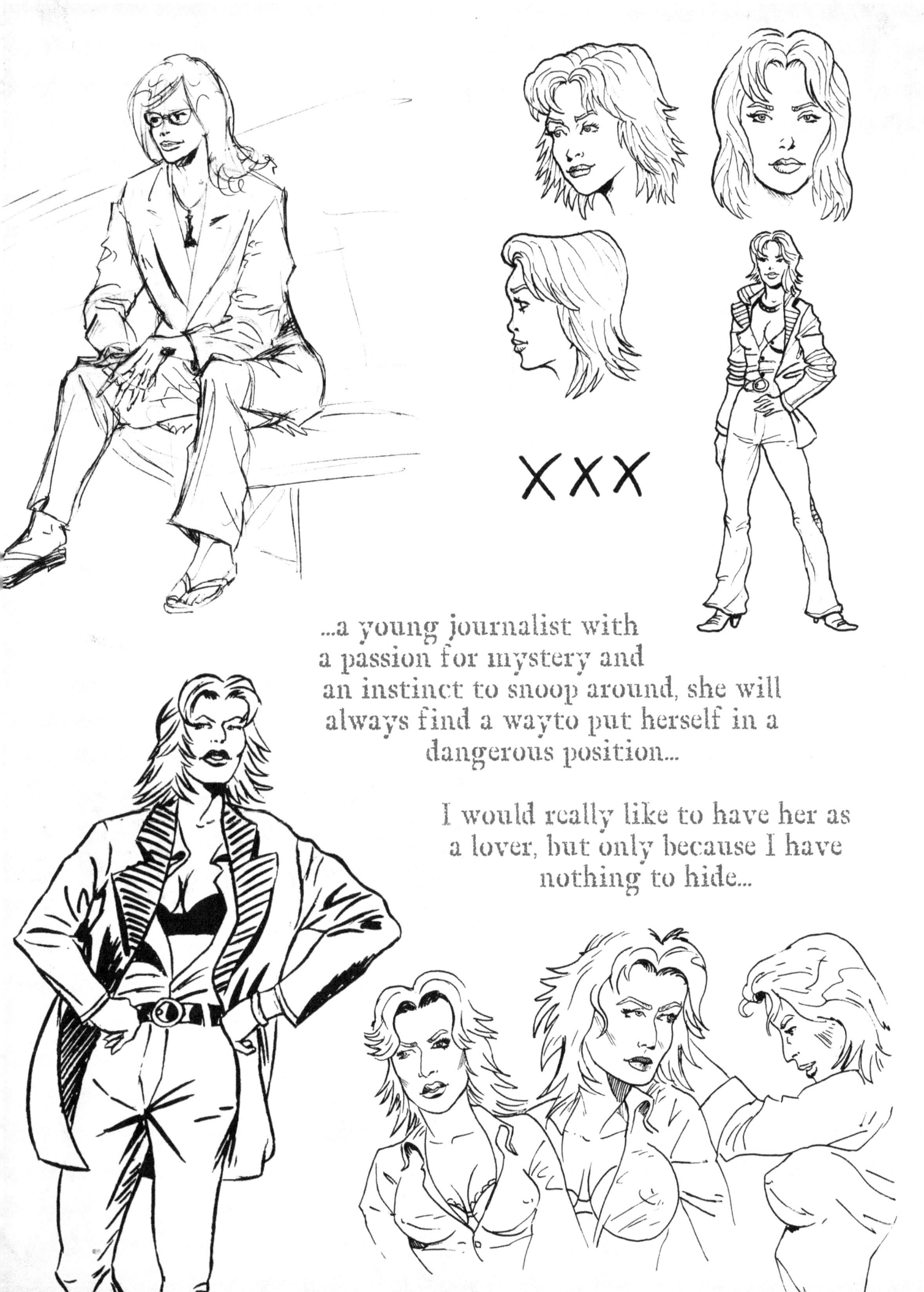

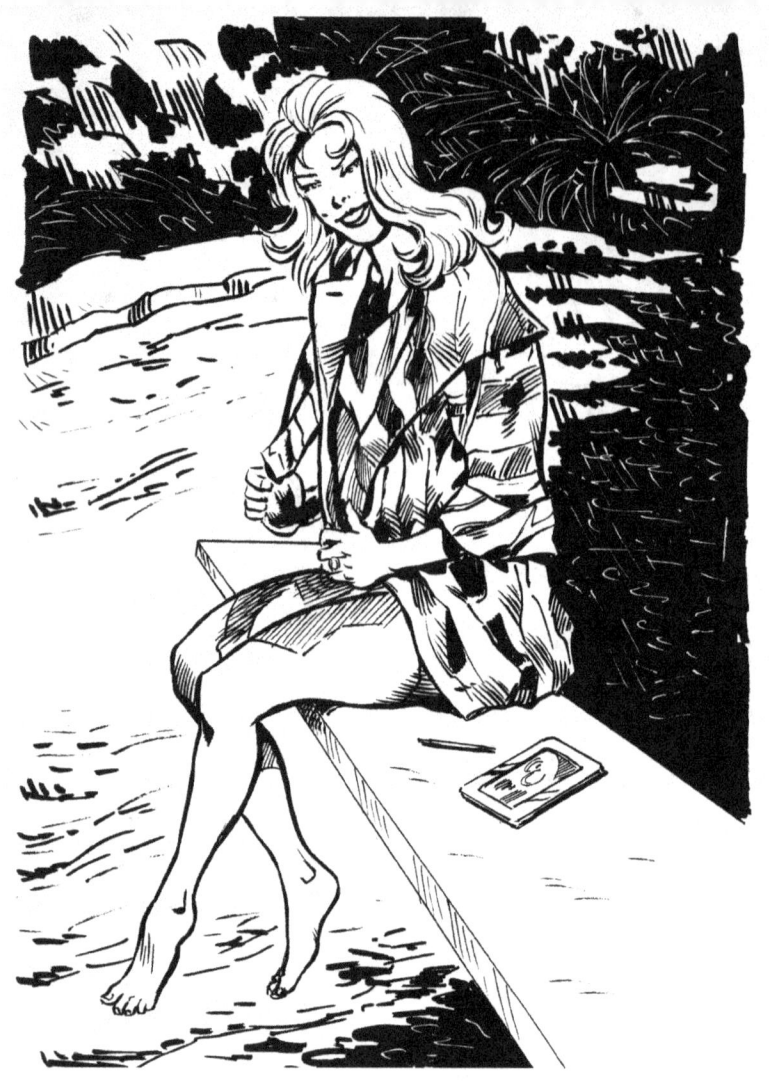

Second course: blonde girl served hot...

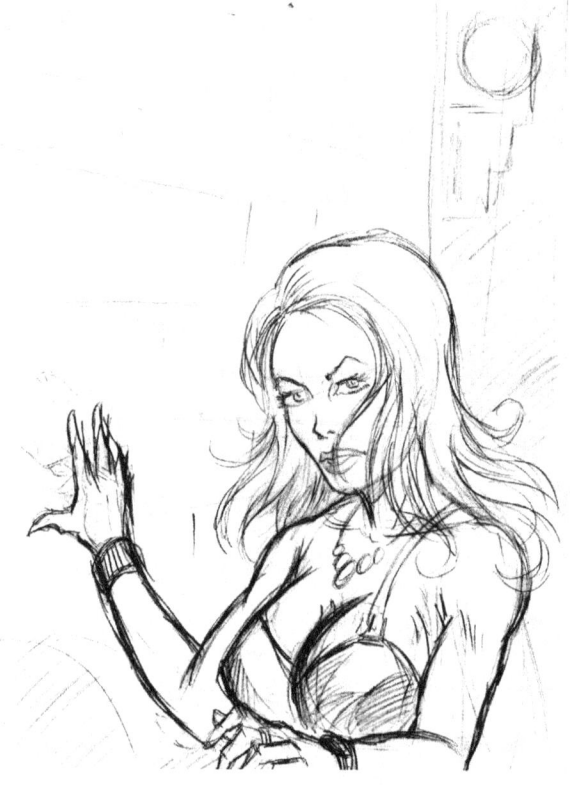

...I wish I could have joined her, but I had to draw an endless number of panels...

...also some pin-ups of her Hawaiian vacation...

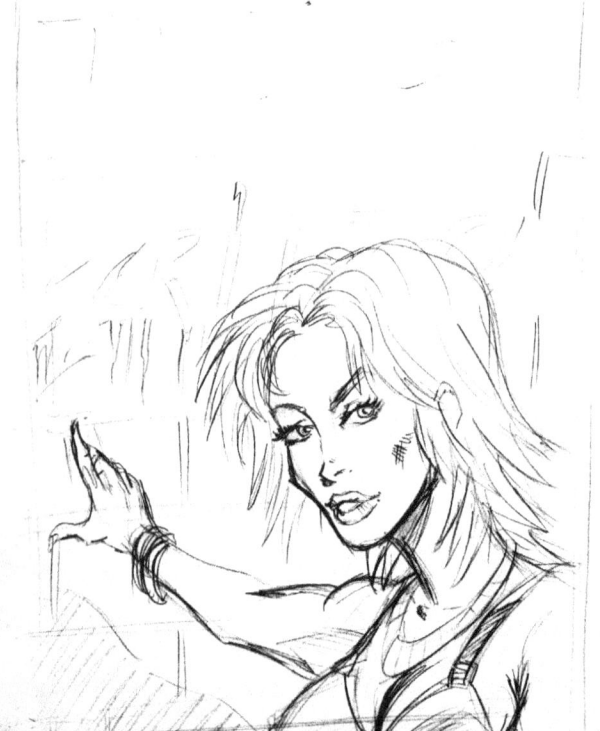
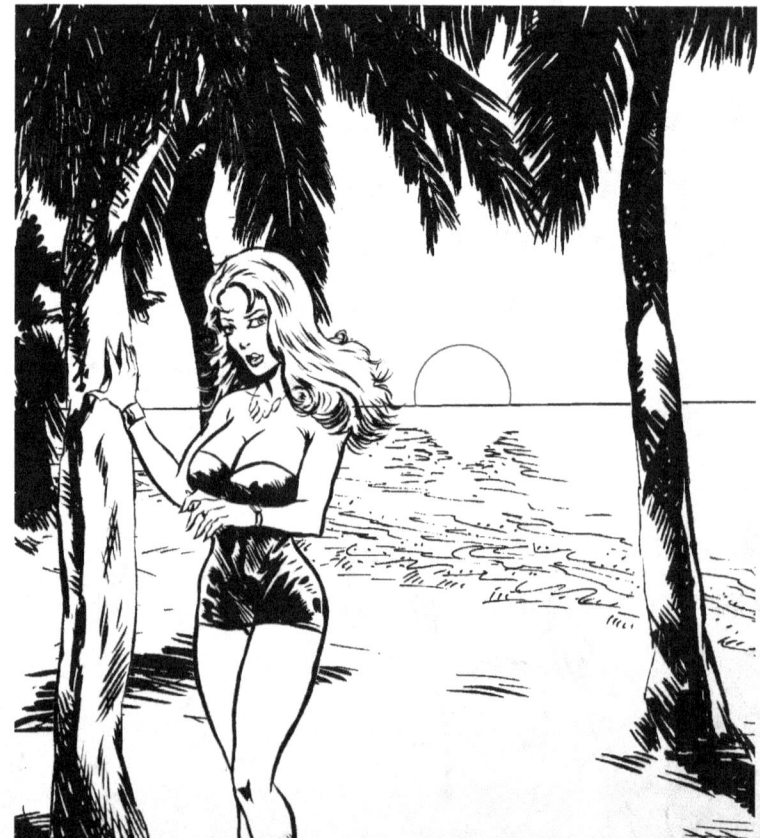

Here, you can find various attempts I did for the cover for #1...

Nick

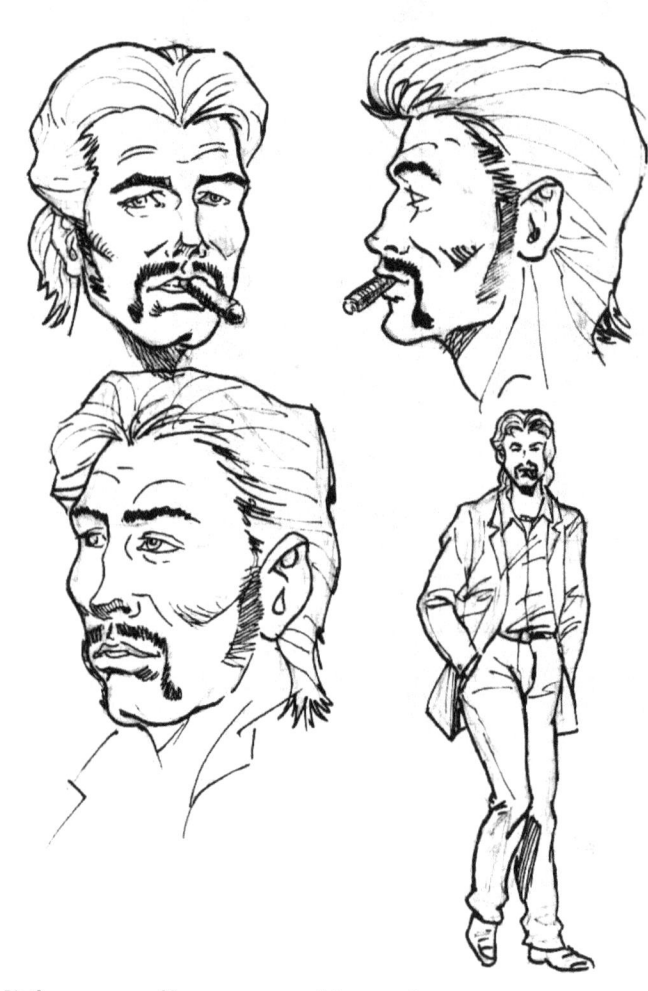

Doubtlessly my favourite character!

He came out to be a mix between actor Franco Nero, Tony Stark and my uncle...

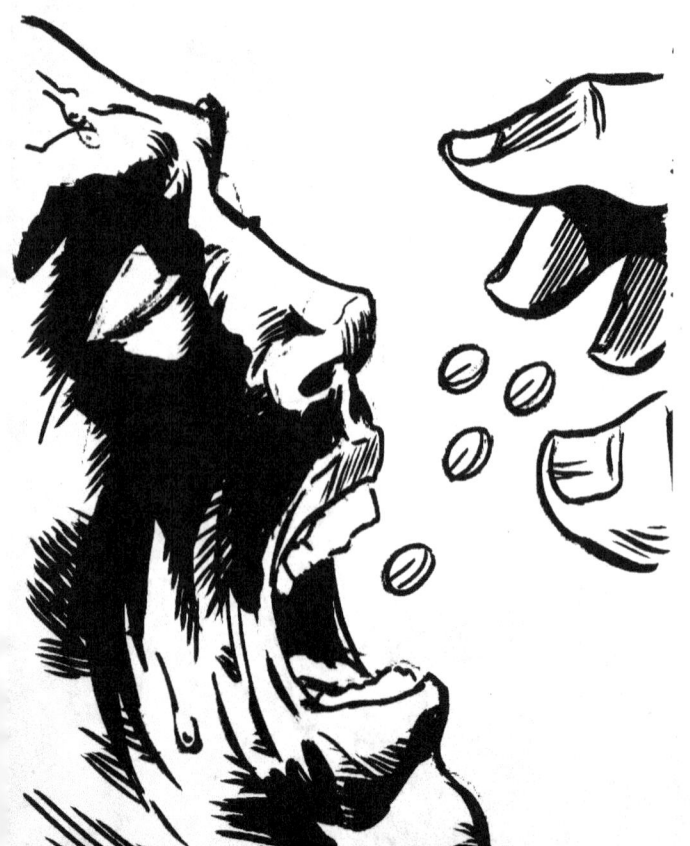

He smokes smelly cigars you can find only in the worst tobacconists of Soho...

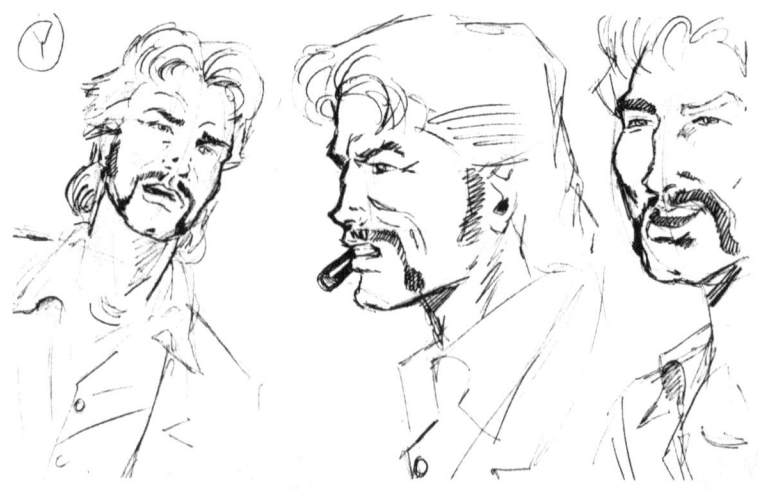

Once a soldier in the British army, he is, now, a Scotland Yard detective.

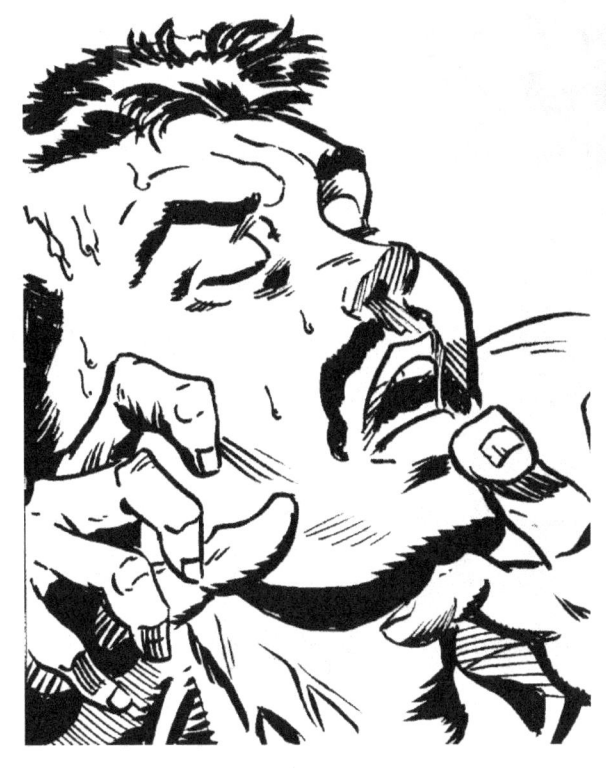

...he is as hard as a nail, but he has also got a golden heart.

He always will do what's right... in a rude way...

...he also have a little problem with his uncontrollable precognitive power...

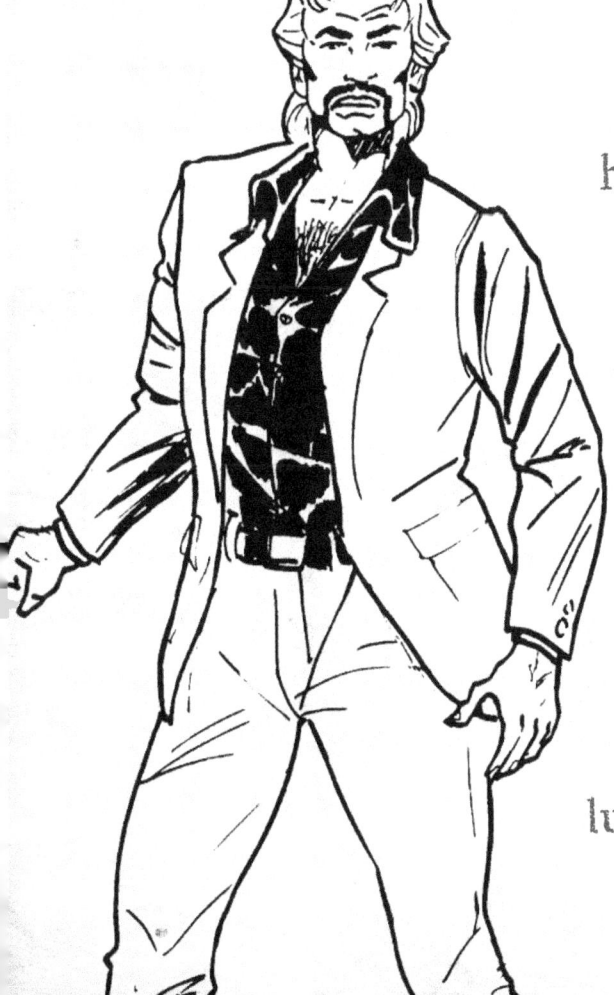

...Nick with his wife, whom I based on my own...

Am I a lucky guy, or not?

Aima

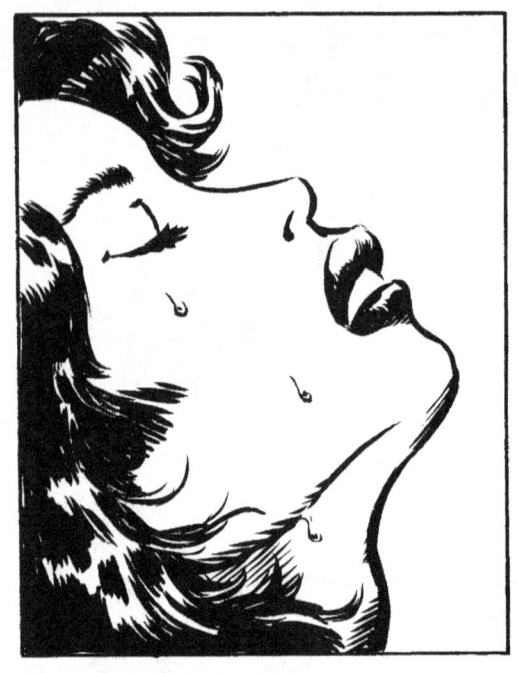
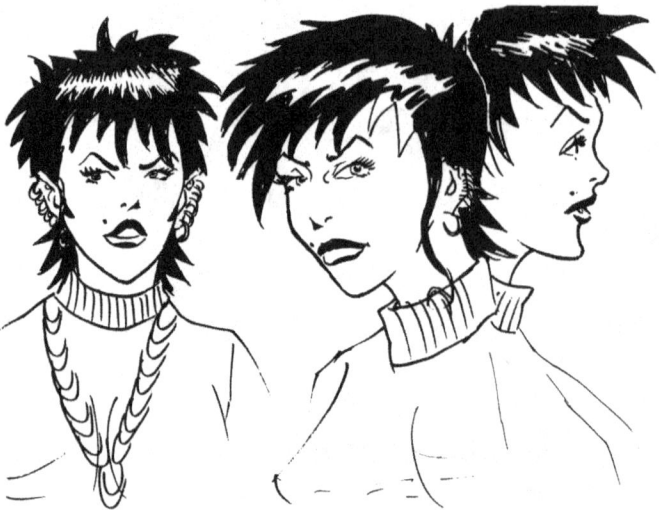

Aima (Ancient Greek word for "blood") is everybody's favourite Powered killer.

She is an emokinetic with the ability to make people blood spontaneously...

EYES UP, GUYS!!!

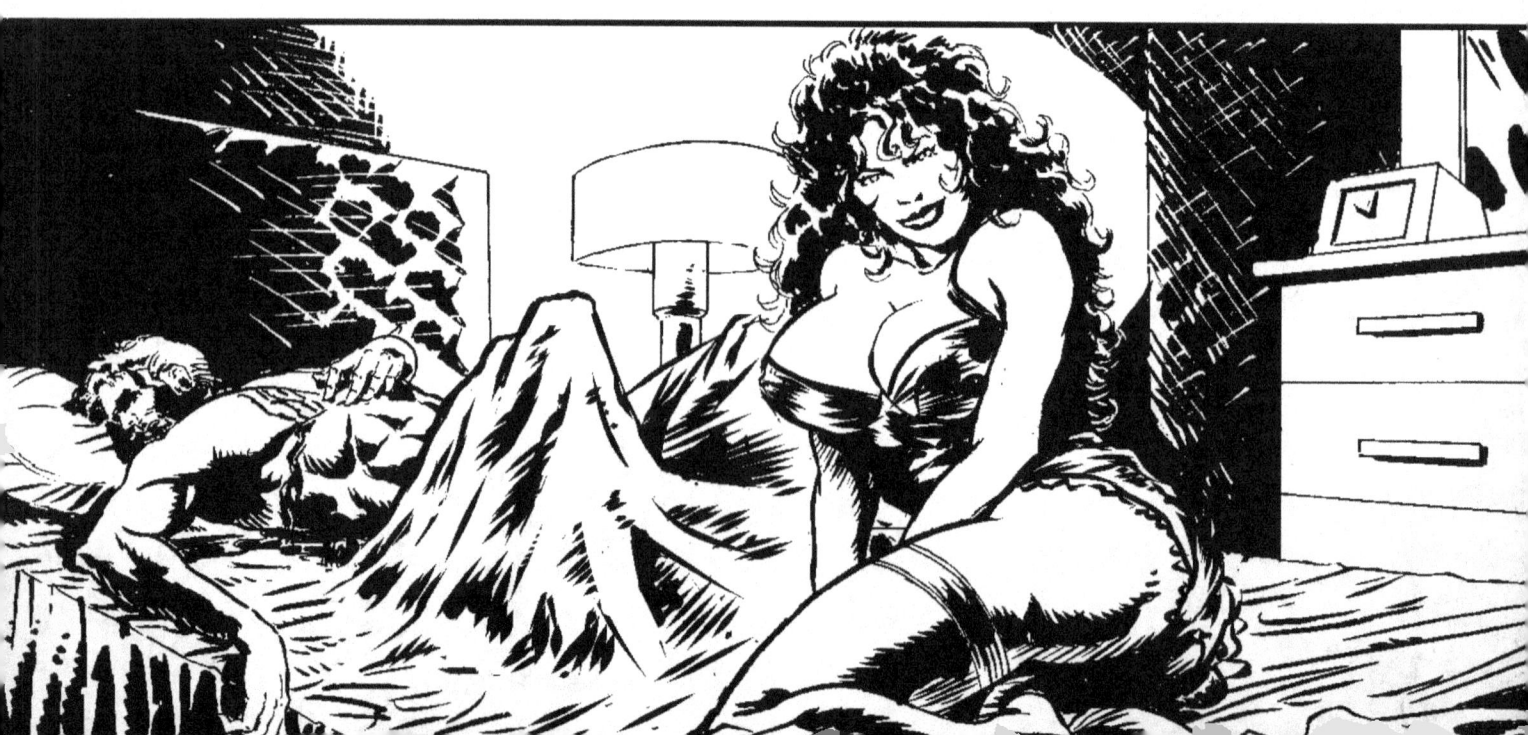

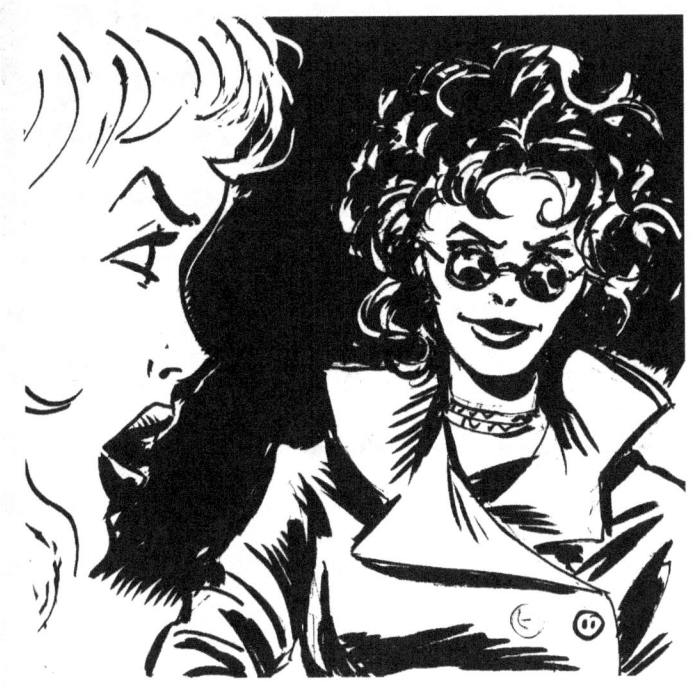

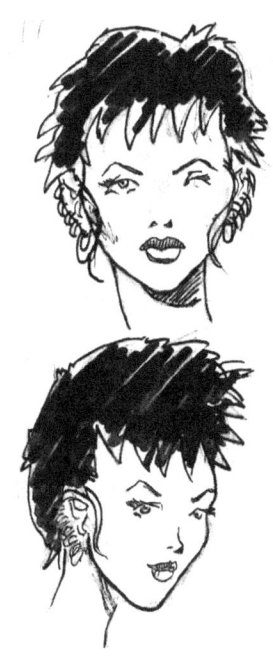
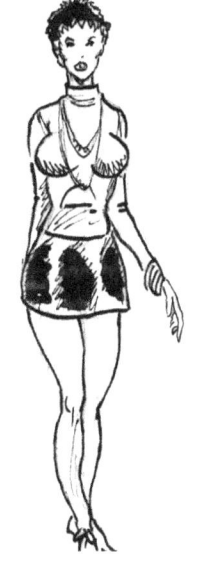

...The more she gets aroused, the better her Power works...

AIMA

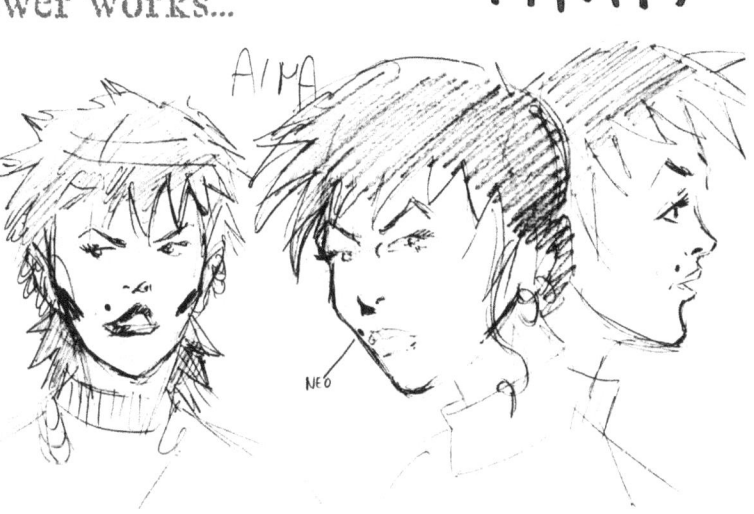

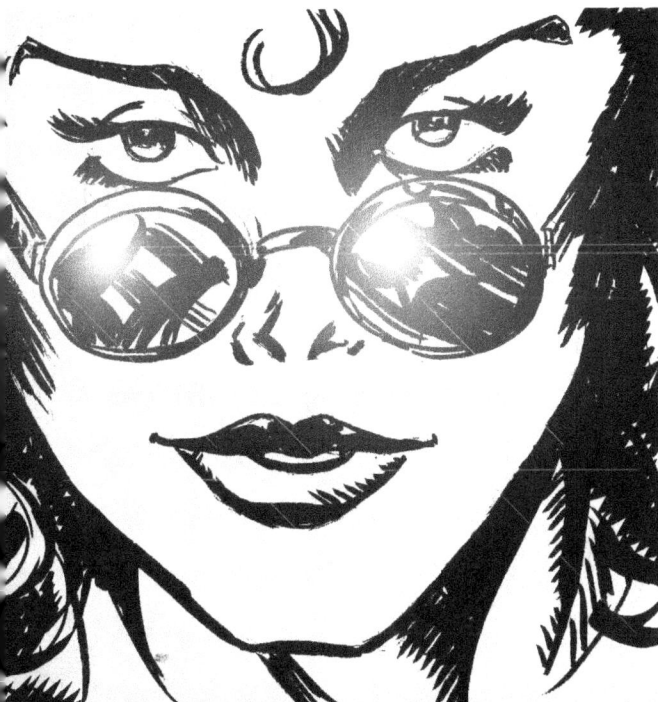

...ruthless, cold-hearted and deceitful, she is the killer, and the weapon mixed together with no chance for detection or identification...

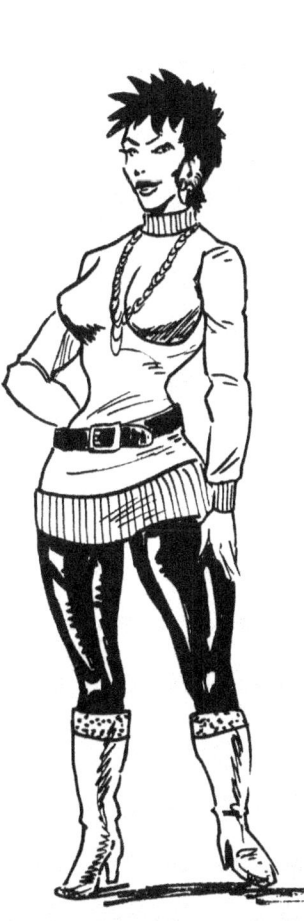

T'NT'eens Chronicles

A superhero story taking place in the U.S, during the Fifties.

The hero is an African-American man who soldiered in WWII...

...and he is in love with his worst enemy...

The first time I read the script, I jumped off my chair...

It was neither a comics nor a graphic novel, but something in between, embellished by animation for the digital market...

...and they wanted a retro style with heavy inking...

My style...

Some character studies follow...

Children of my sleepless nights
And of gallons of coffee...

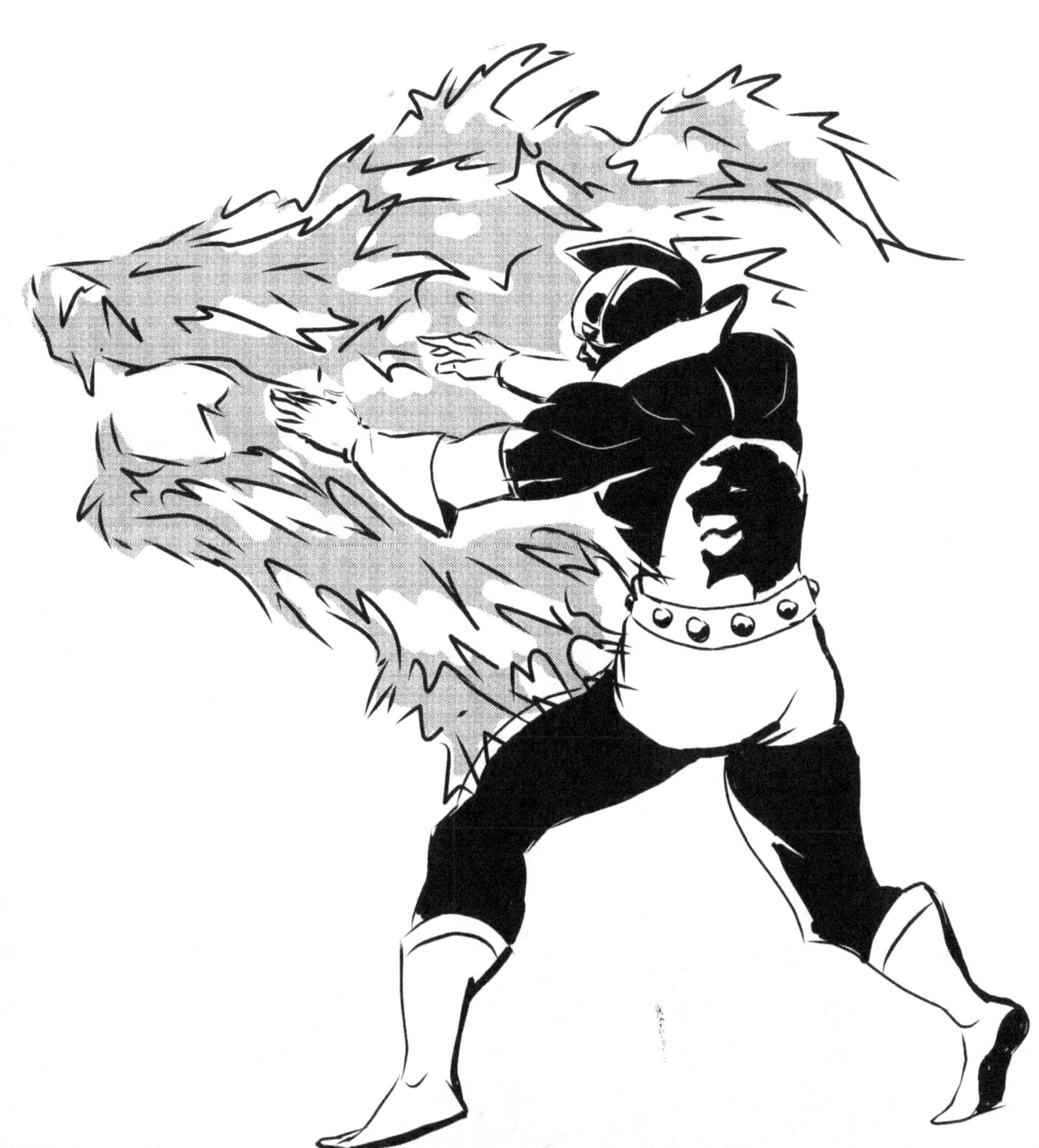

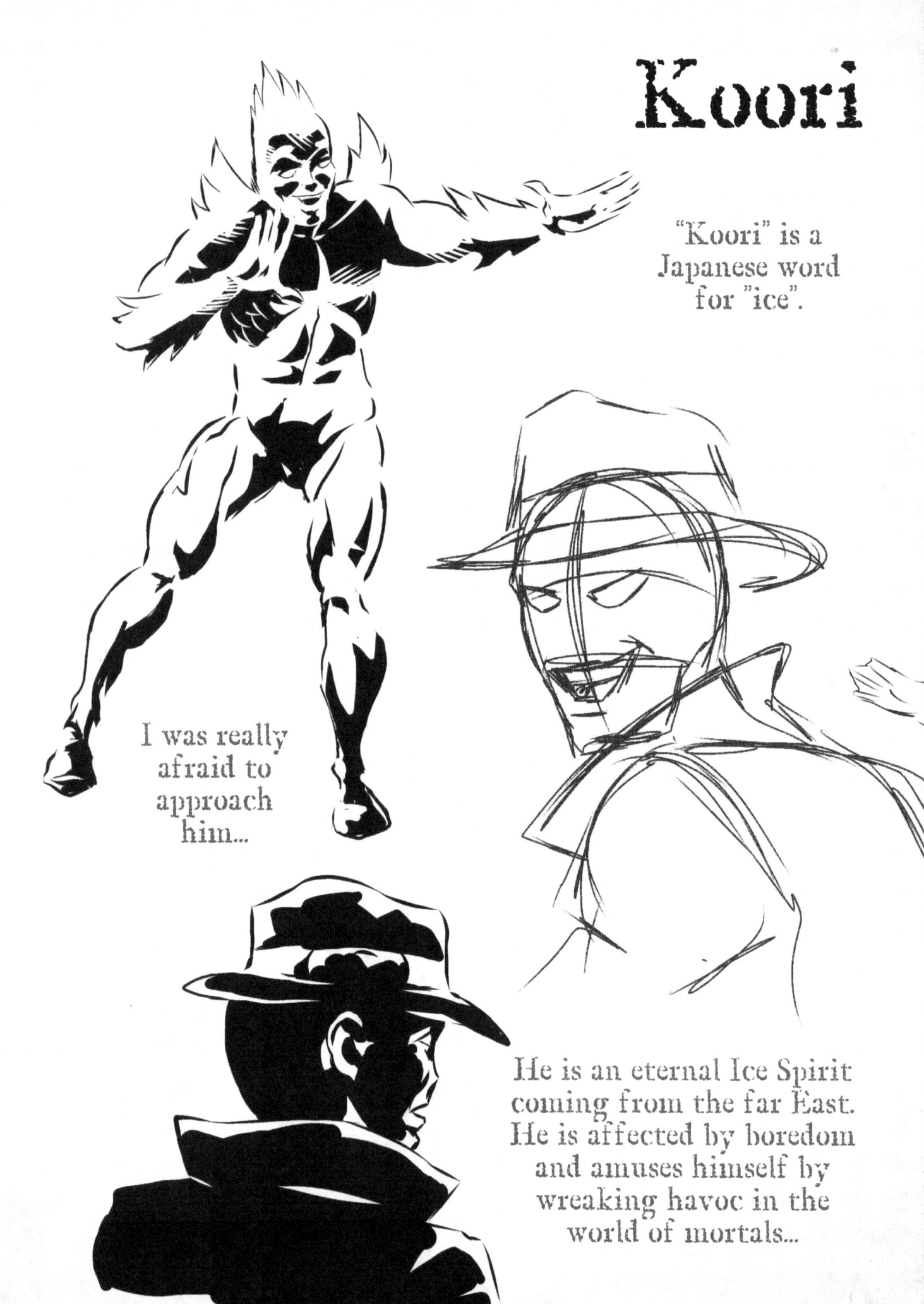

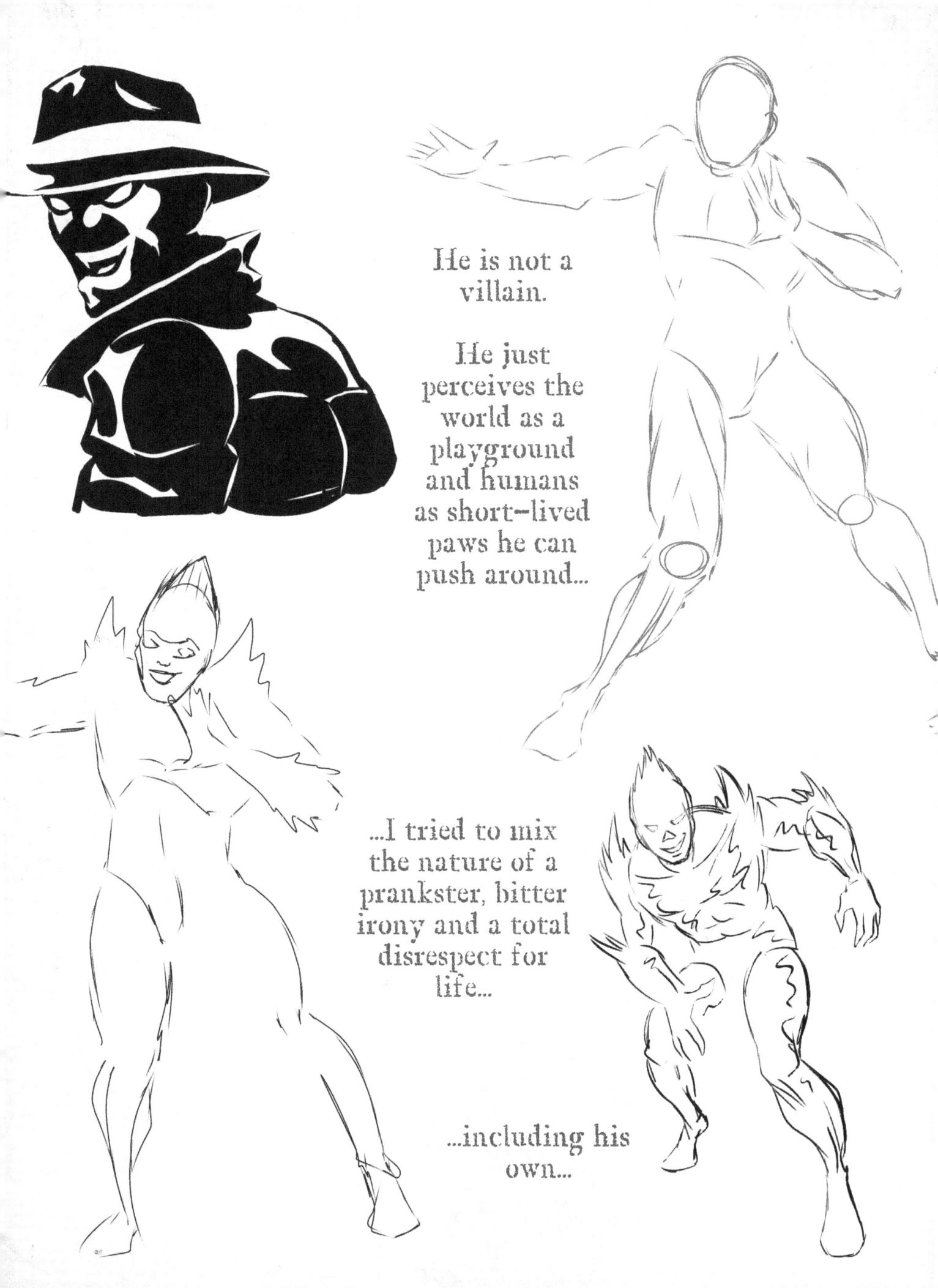

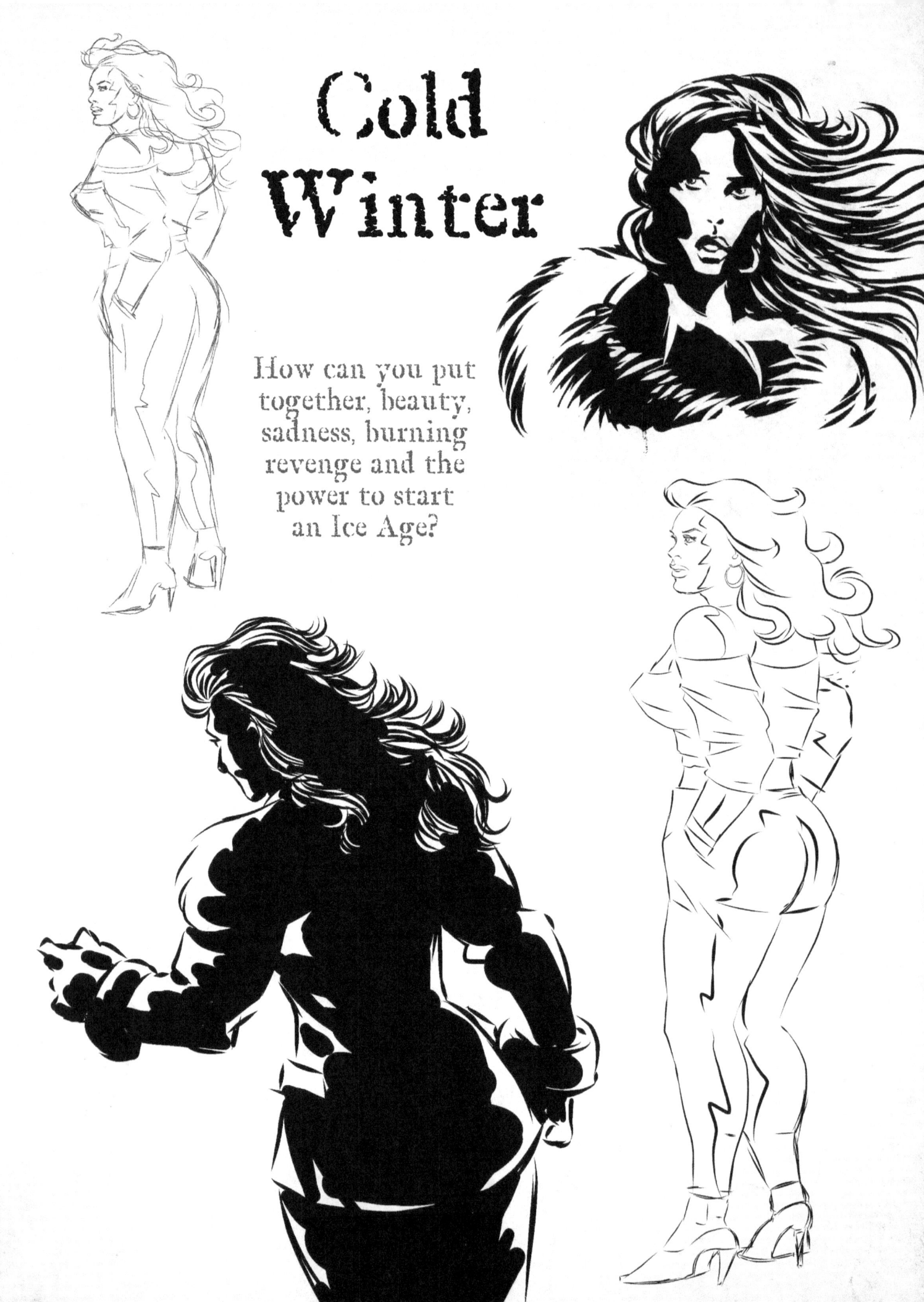

Cold Winter

How can you put together, beauty, sadness, burning revenge and the power to start an Ice Age?

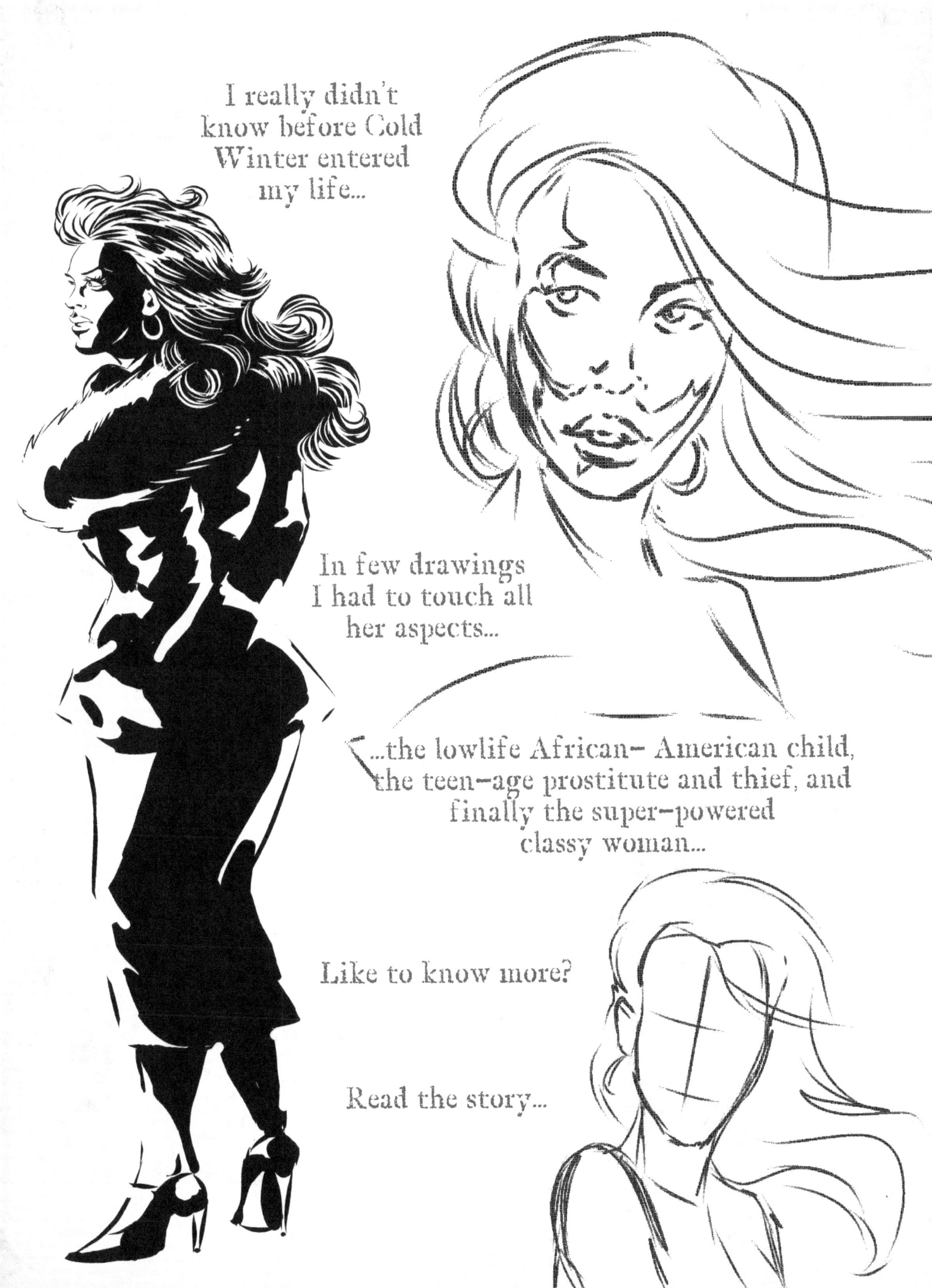

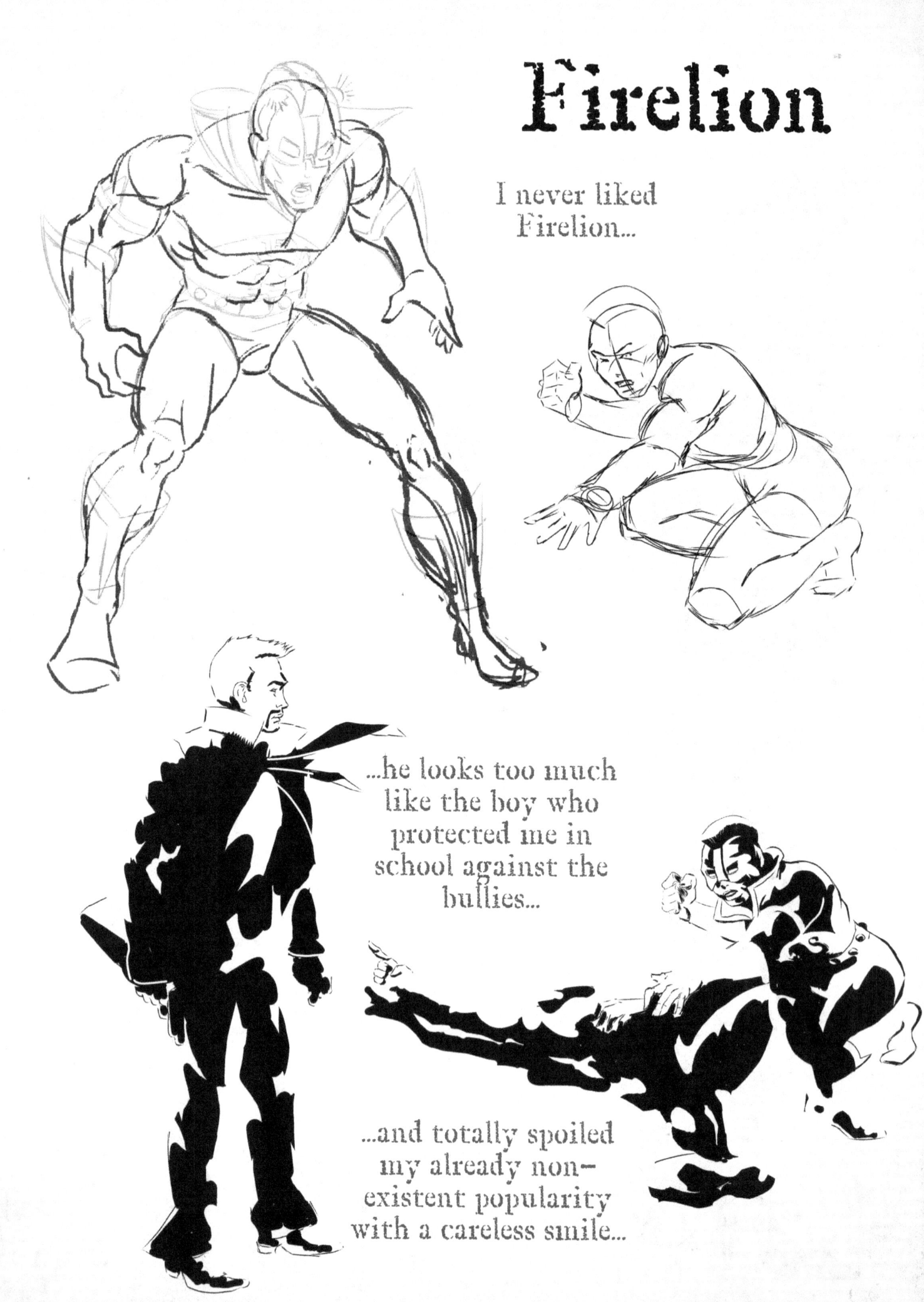

...with my schoolmate in mind I went to my drawing table.

The result is a powerful man, with a focused mind a the body of a Greek hero sculpted in ebony.

On the other hand, it was also my chance to get some revenge...

...since I read the script in advance I knew he was going to get his share of kicks...

Cops, Criminals and everything else...

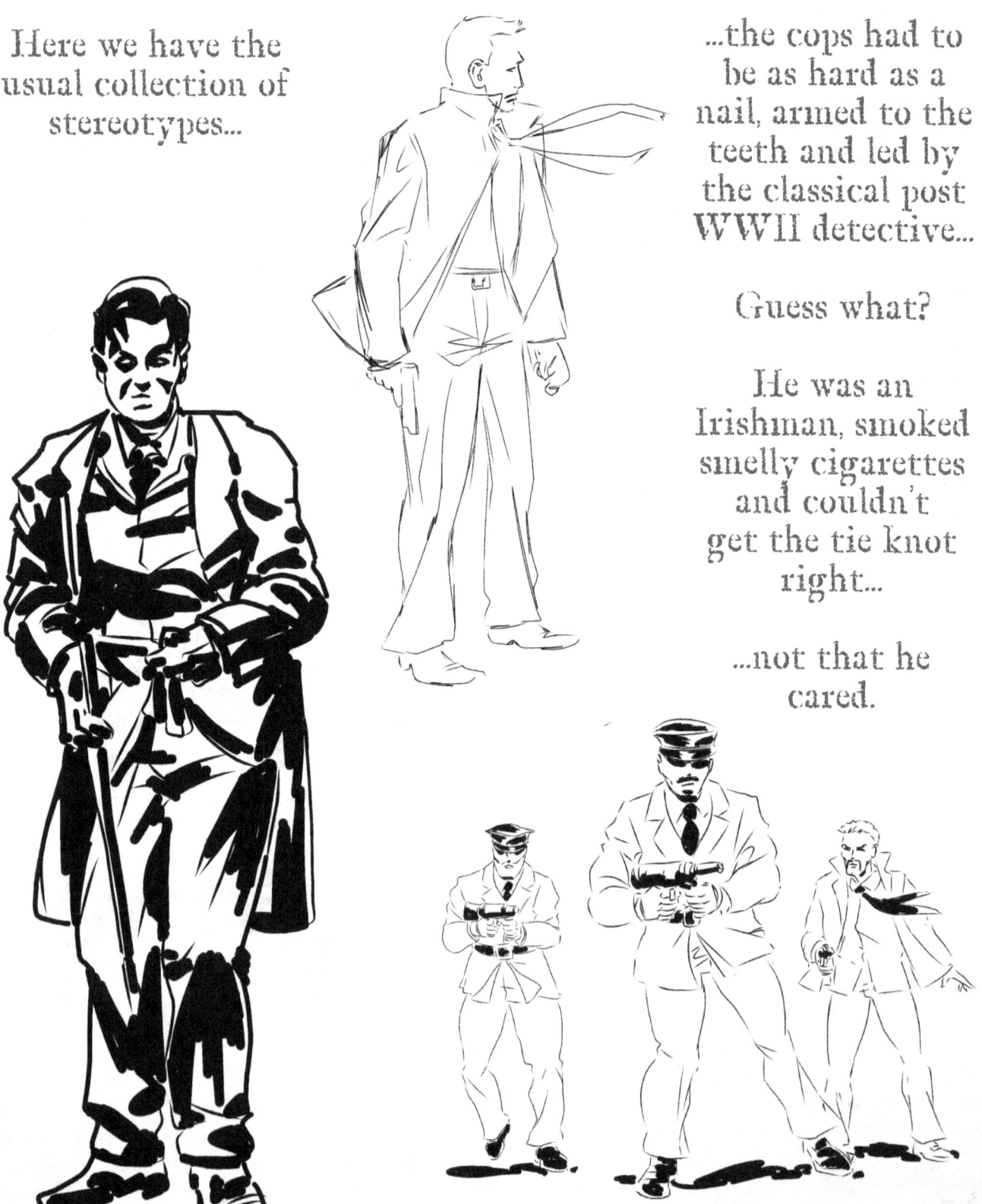

Here we have the usual collection of stereotypes...

...the cops had to be as hard as a nail, armed to the teeth and led by the classical post WWII detective...

Guess what?

He was an Irishman, smoked smelly cigarettes and couldn't get the tie knot right...

...not that he cared.

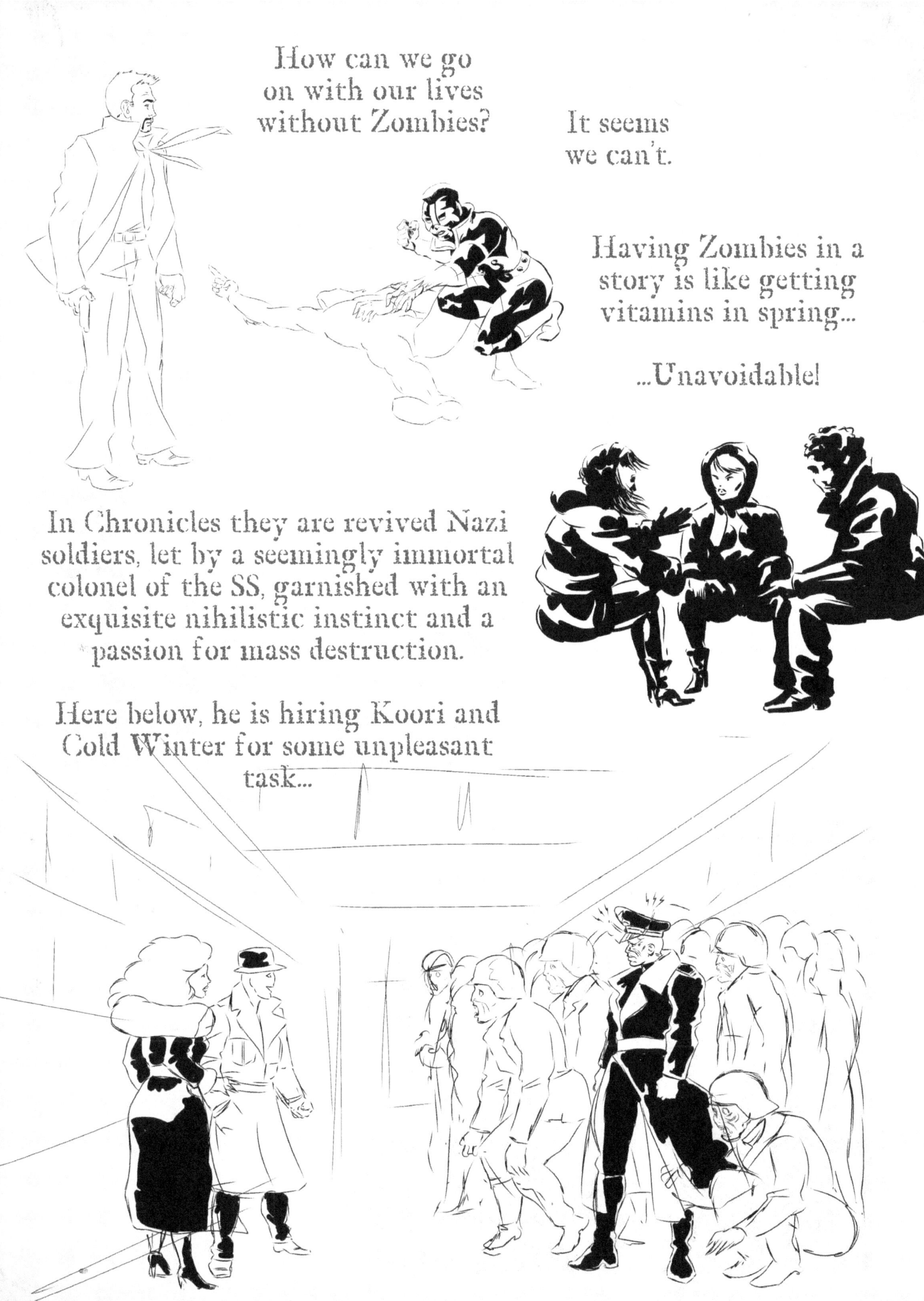

The Kiss

The story begins with a kiss.

It was the most difficult panel I had to draw...

It is a passionless kiss, sold for money.

The first step toward a ruthless killing...

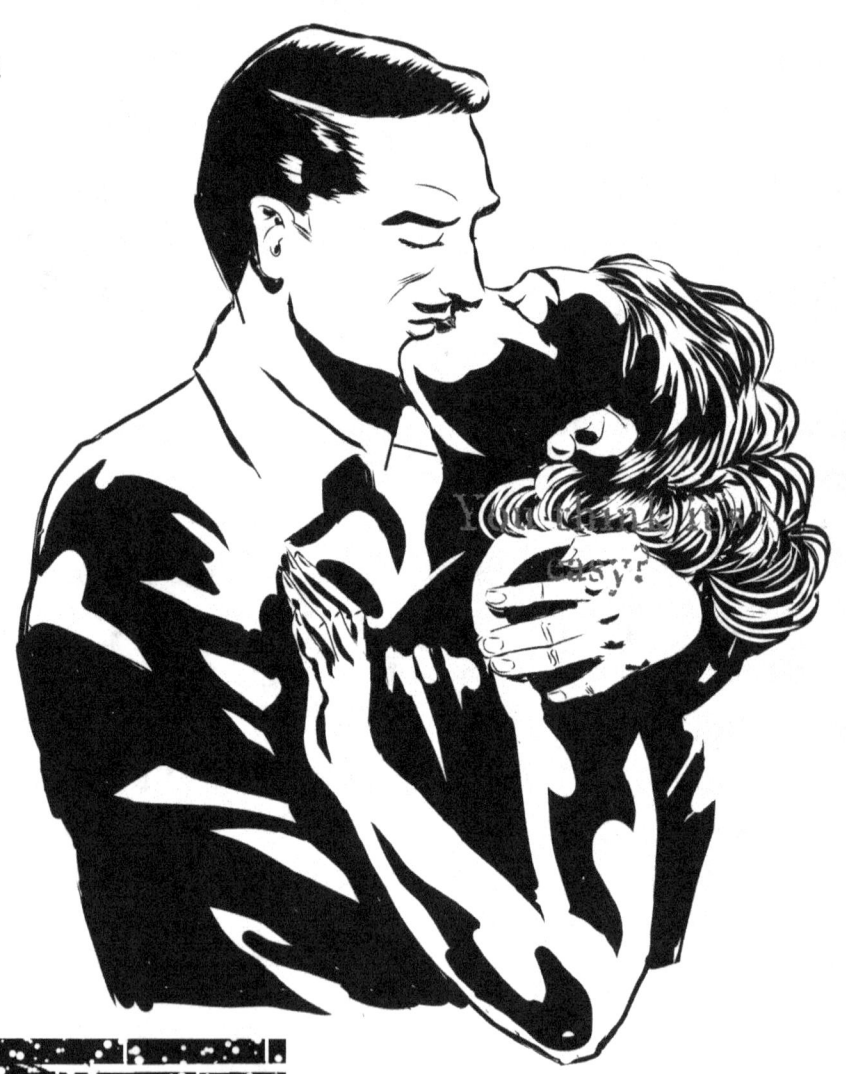

...and yet it had to look like a movie kiss...

...eye connection, lips connection...

Just before the worst happens...

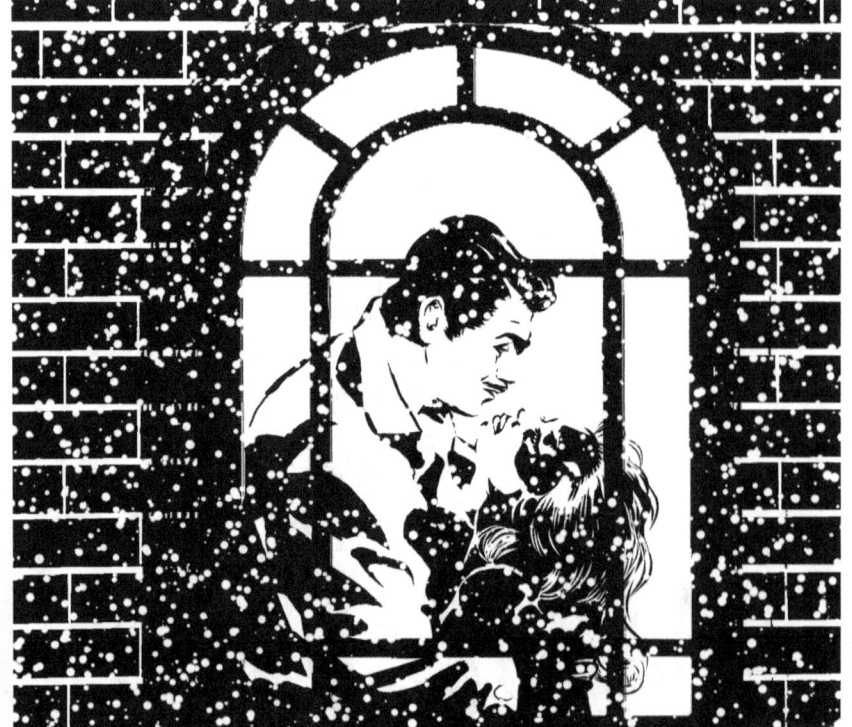

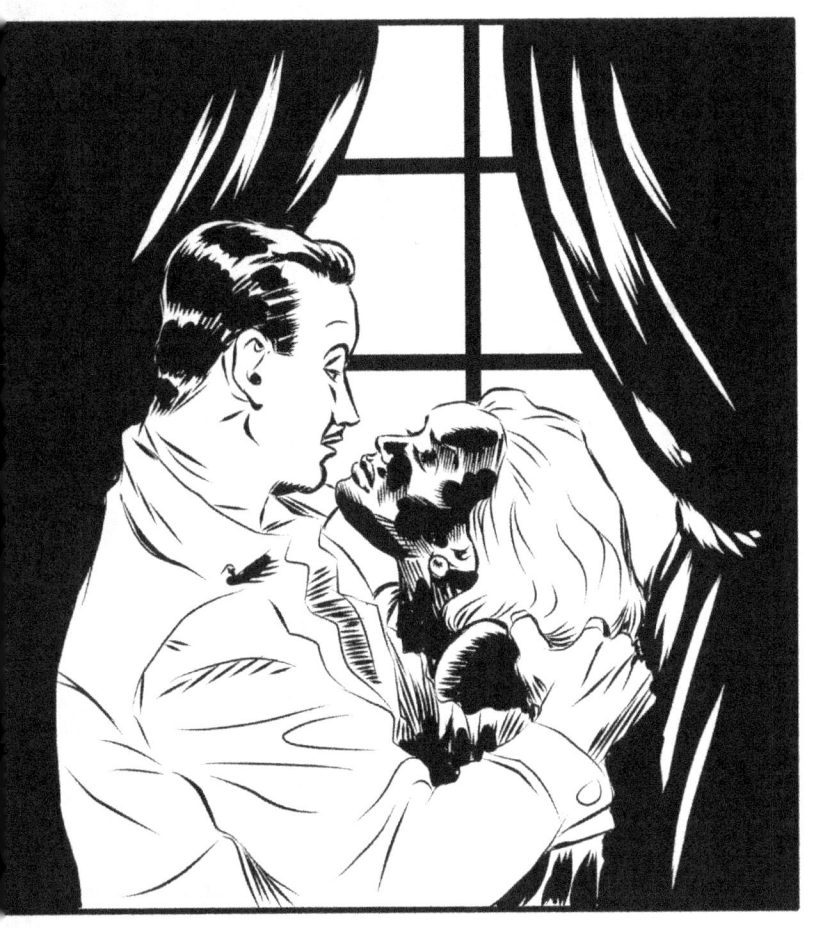

You think it's easy?

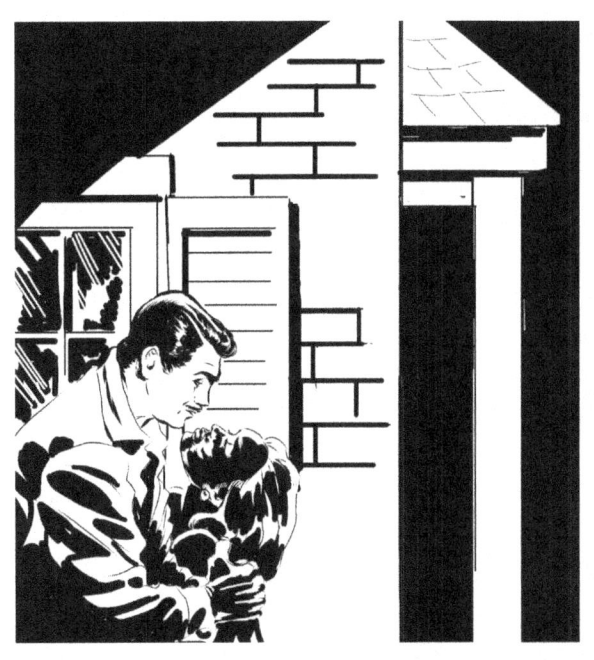

Try to draw it yourself and save me hours of sleepless artistic anxiety...

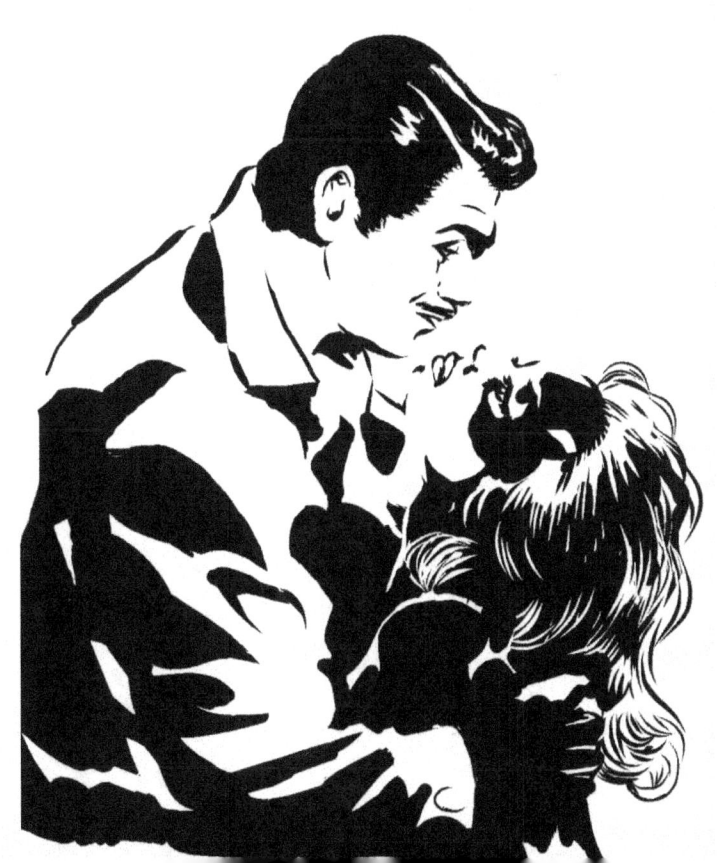

Golden Age

There is much to say about the Golden Age of comics that I do not really know where to start.

As I delved myself in the graphical study of the characters, the places, and the historical events for the Public Domain Encyclopedia (or PDE) project, I started feeling a closeness to the fictional people that populated the funny pages of times past.

Maybe it is true that those were simpler times in which a good one-twos could KO a villain and solve the problem.

In the same time it was a time of experimentation, wild ideas, new creations and attempts to reach the unreachable through mystery, heroic behaviour and beauty.

A hidden society of powerful and focused activists clashed with the expansionism of the Nazis, war was a reality and the enemy right on the porch...

This is how the Age of Gold of comics looked to me...

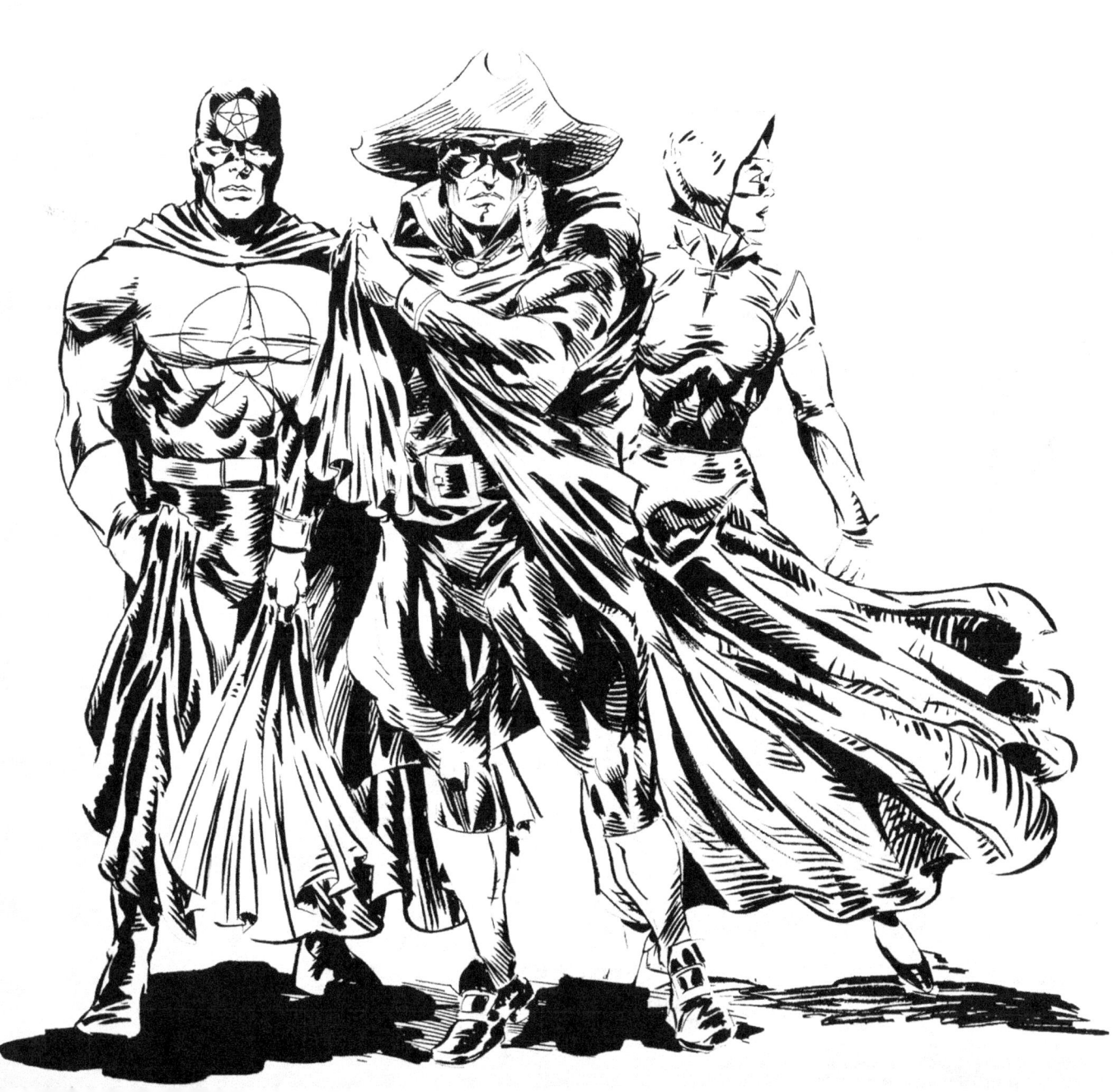

Heroes and Heroines

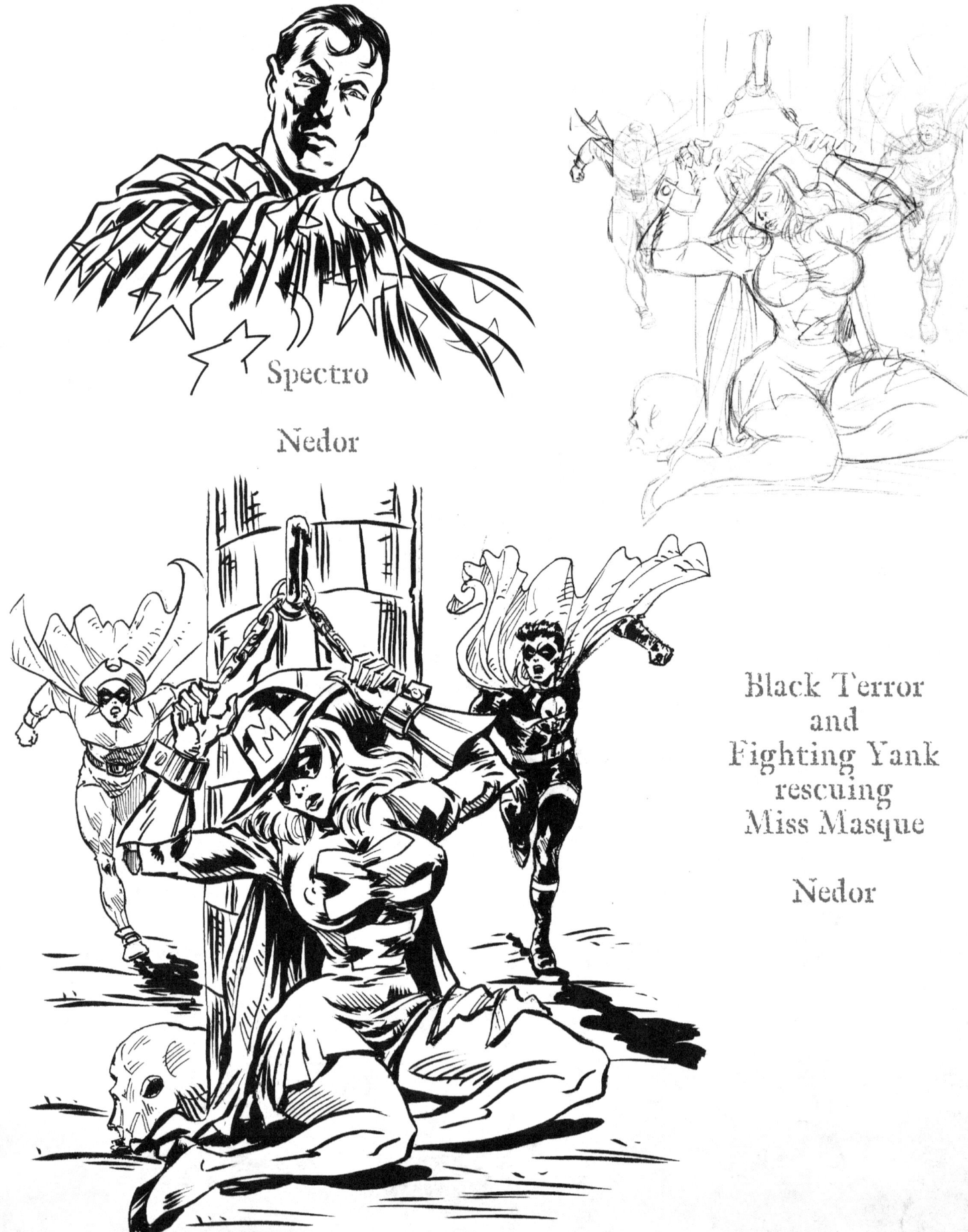

Spectro

Nedor

Black Terror and Fighting Yank rescuing Miss Masque

Nedor

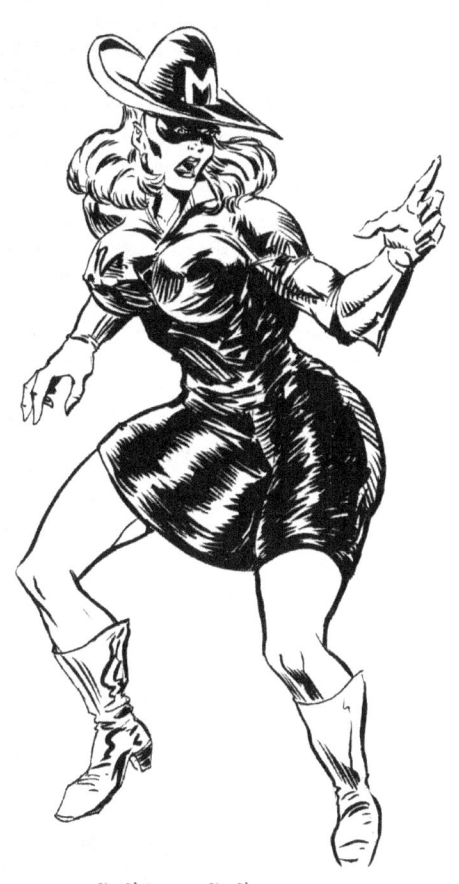

Miss Masque

Nedor

Phantom Detective

Nedor

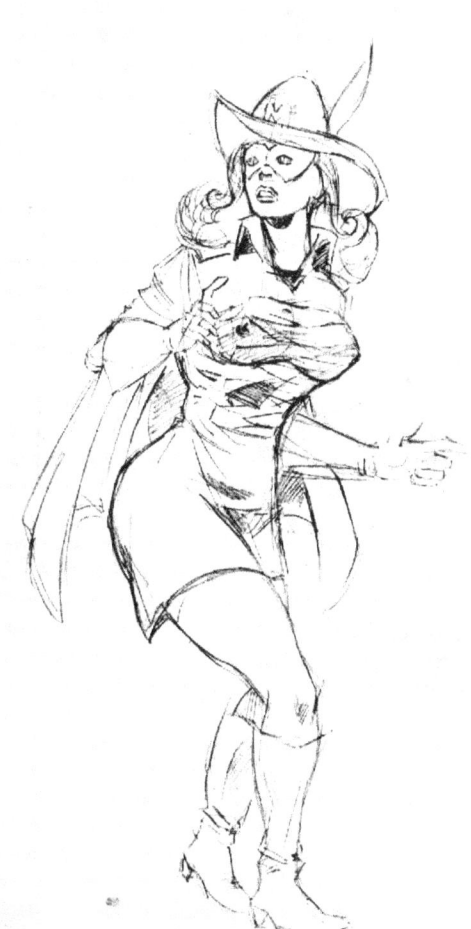

Black Bat

Nedor (from the pulp books)

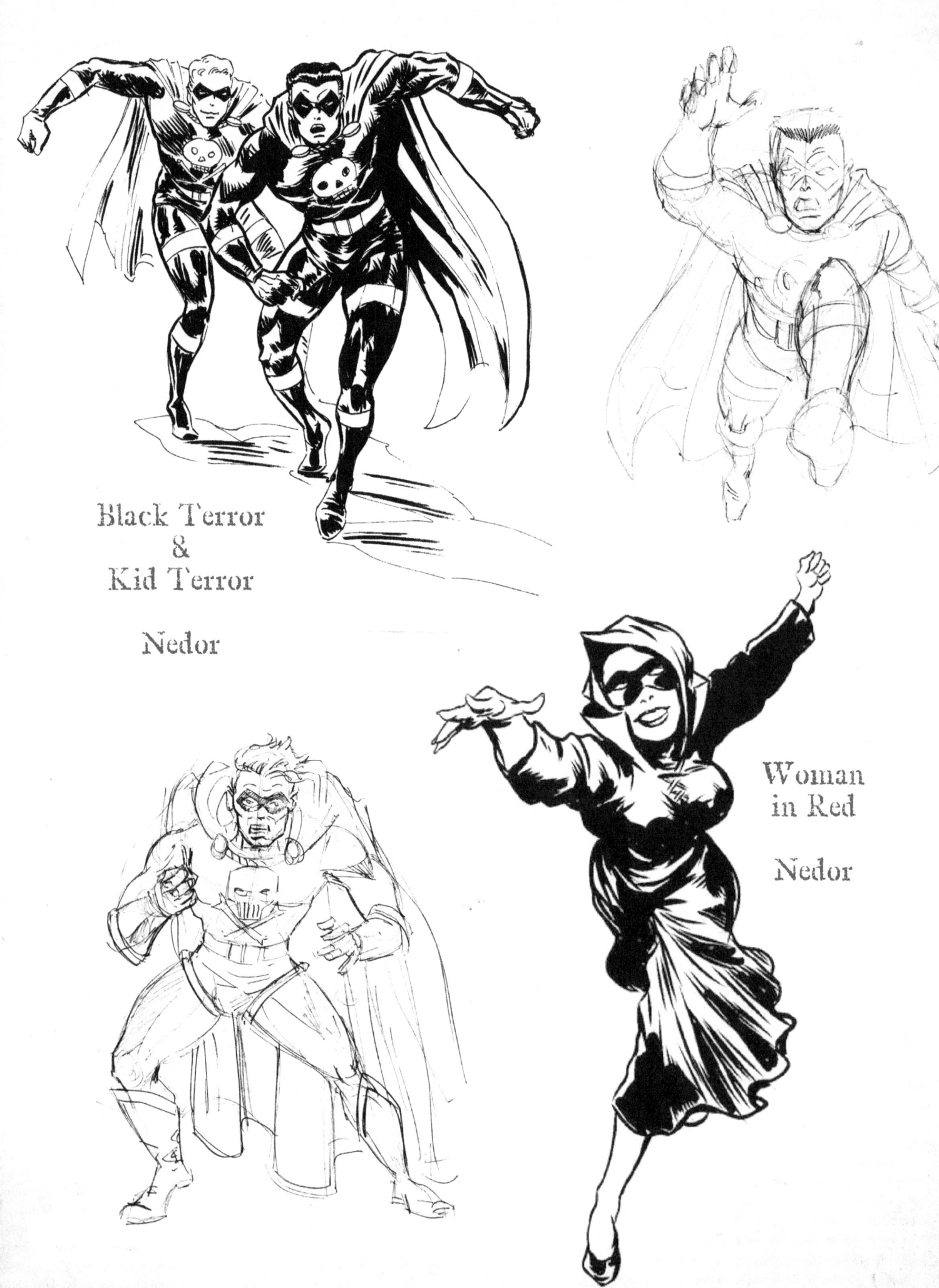

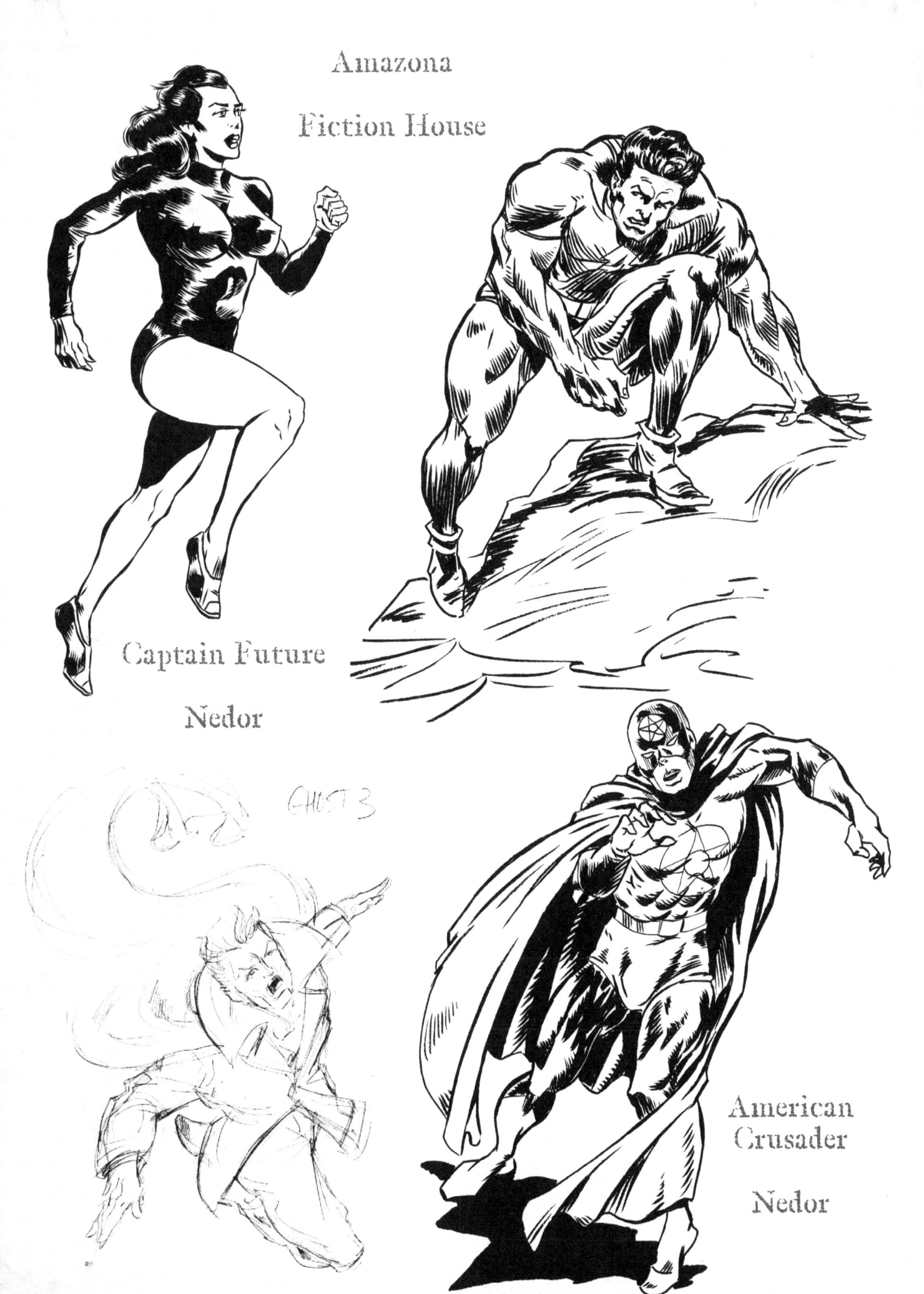

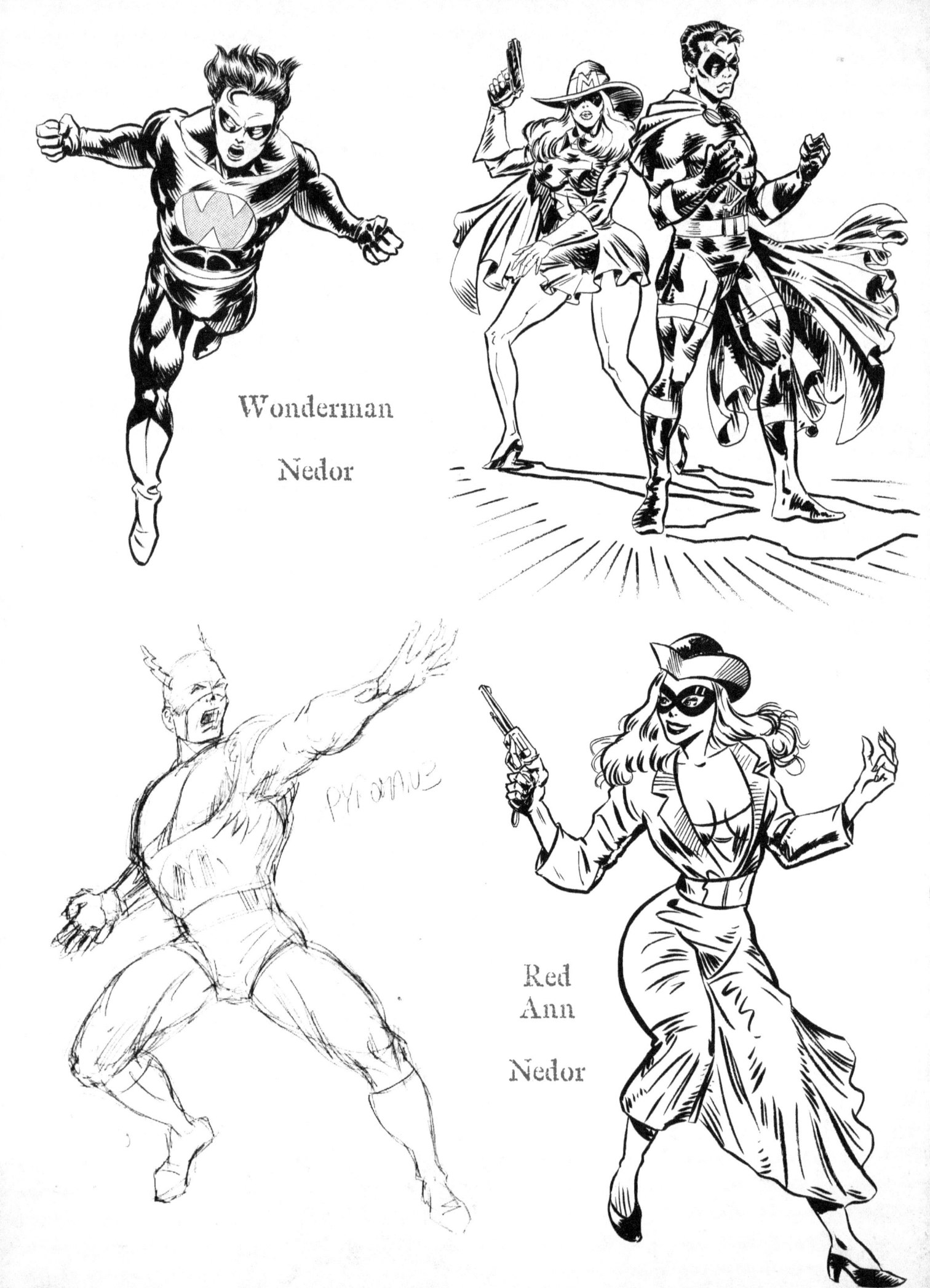

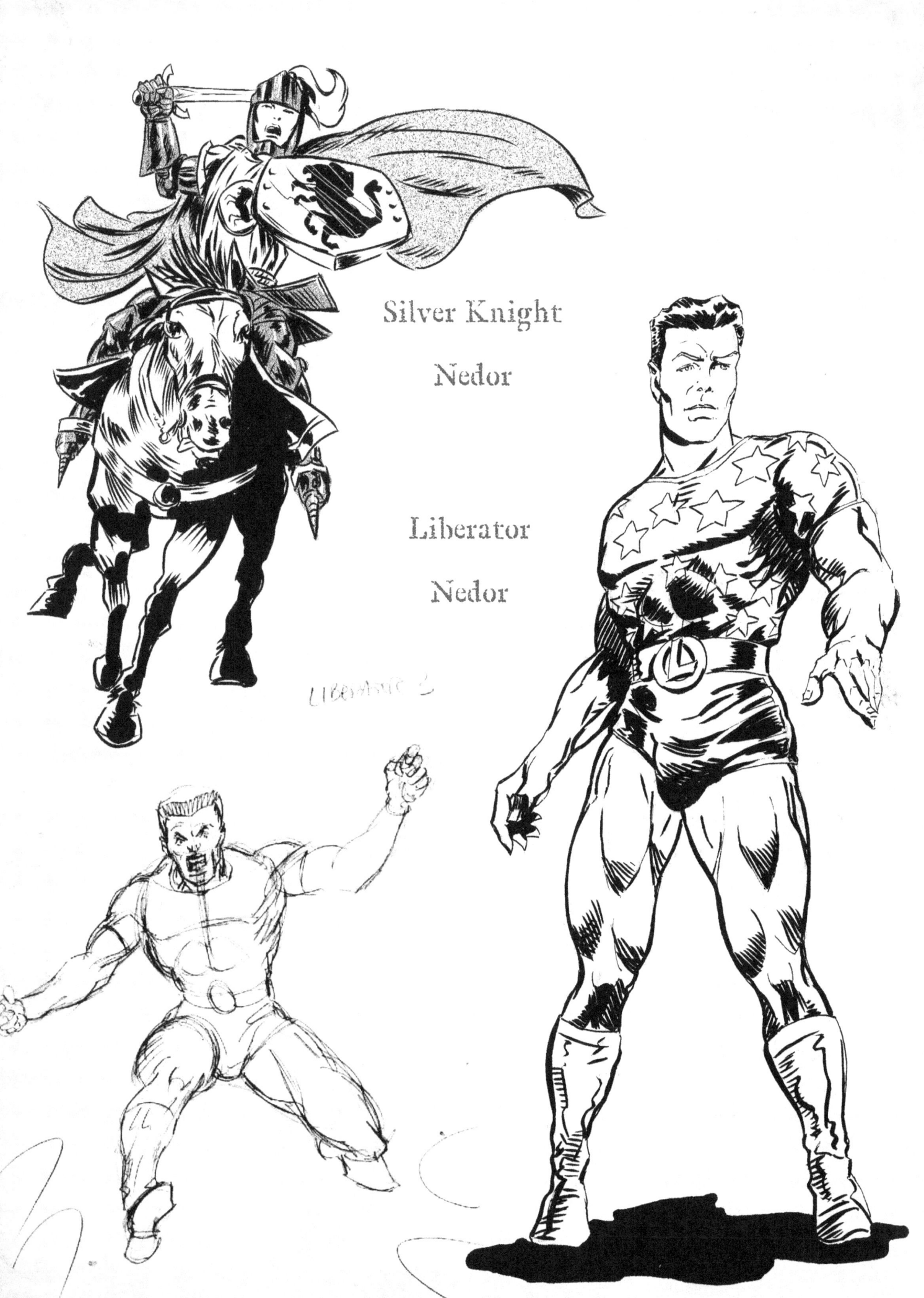

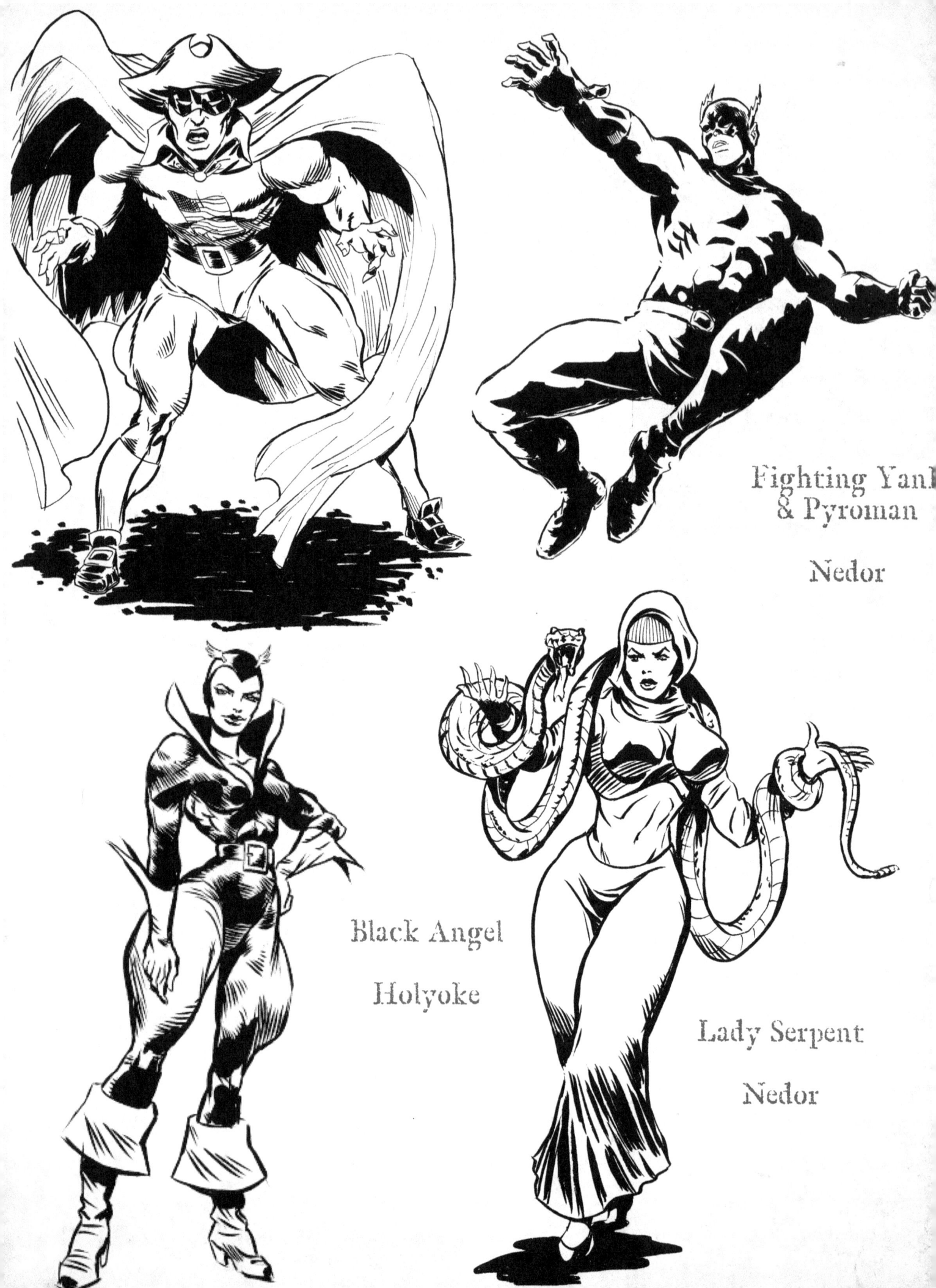

Fighting Yank & Pyroman

Nedor

Black Angel

Holyoke

Lady Serpent

Nedor

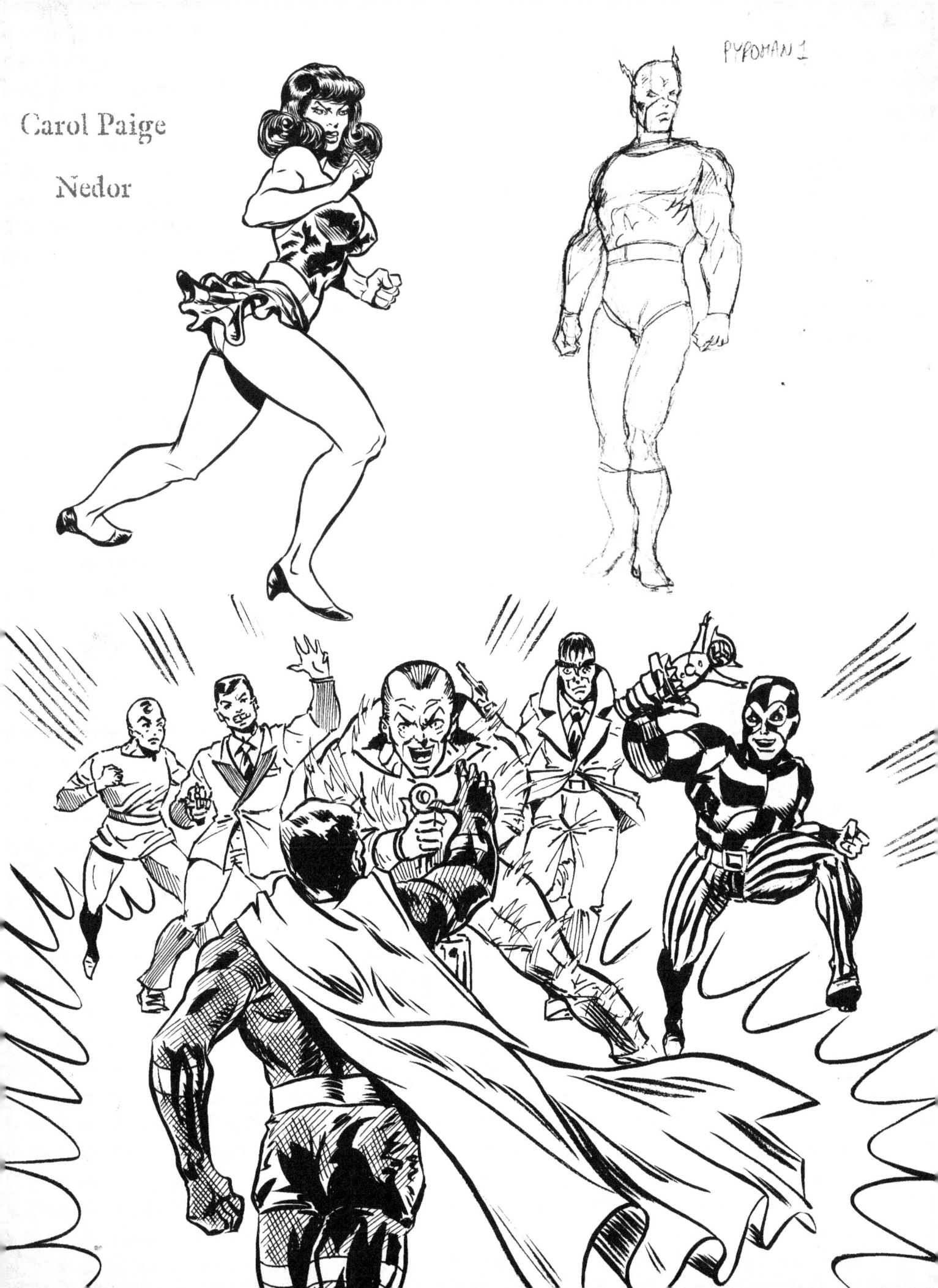

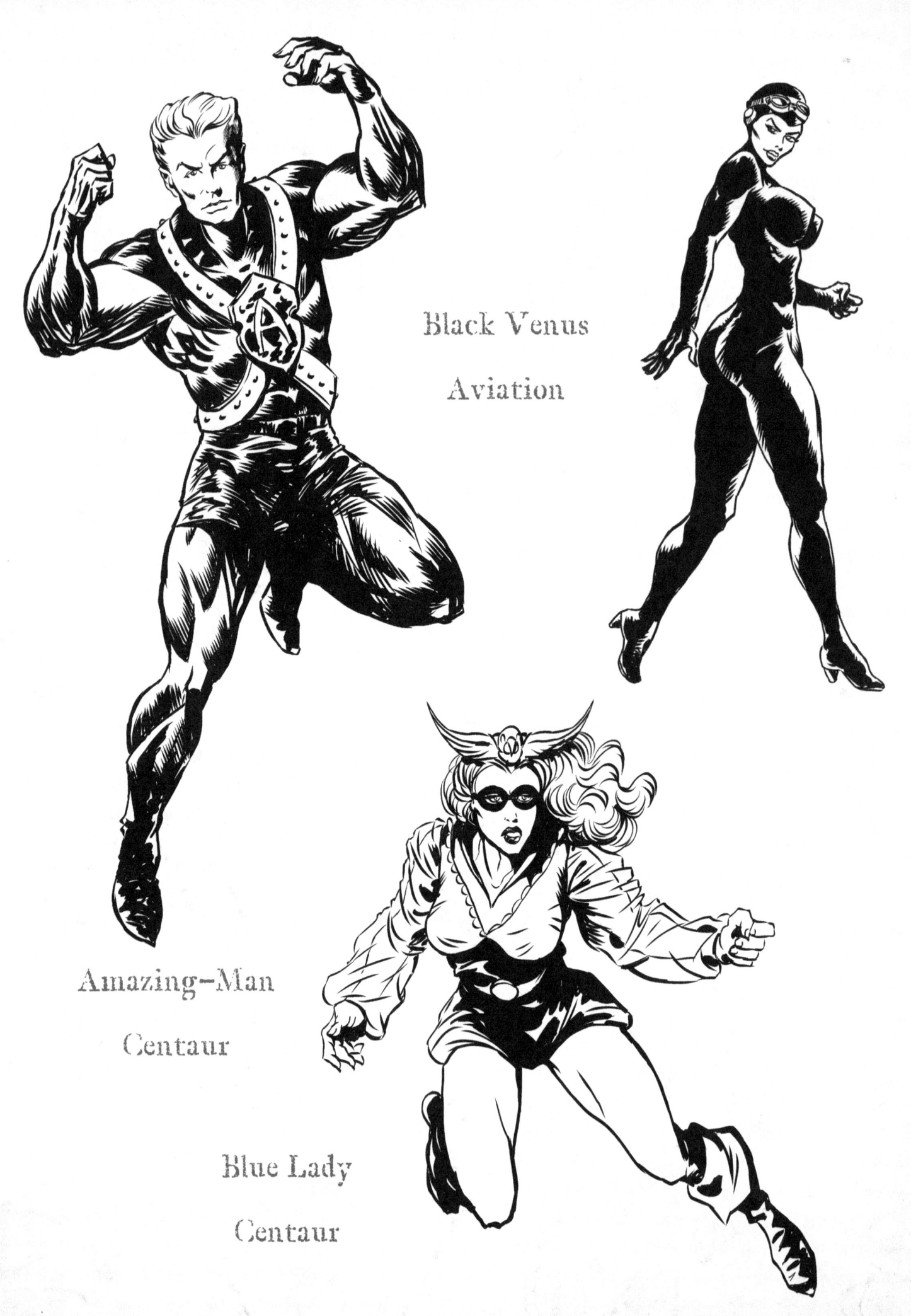

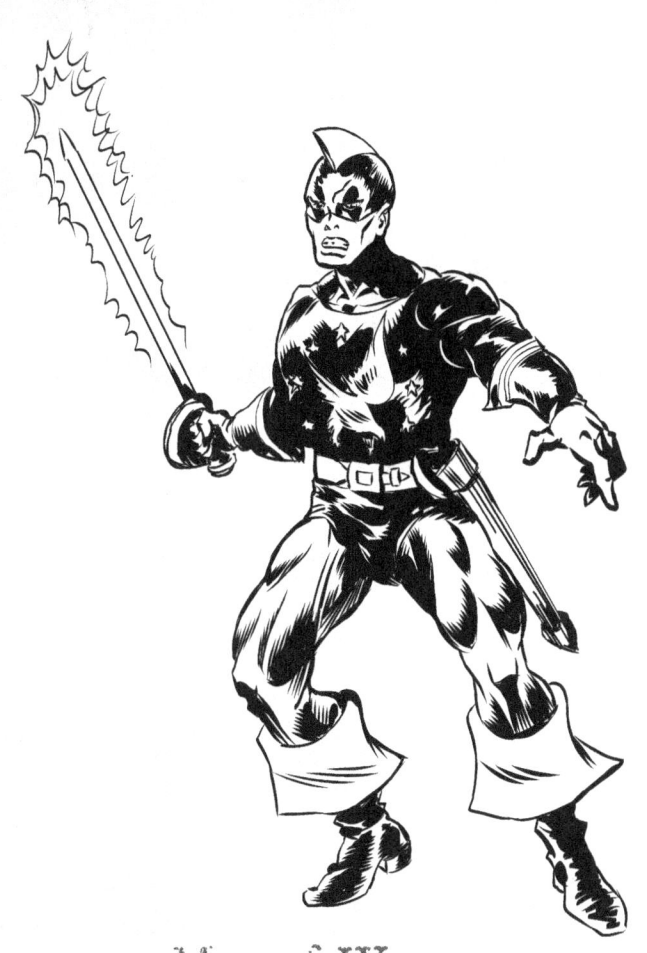

Man of War

Centaur

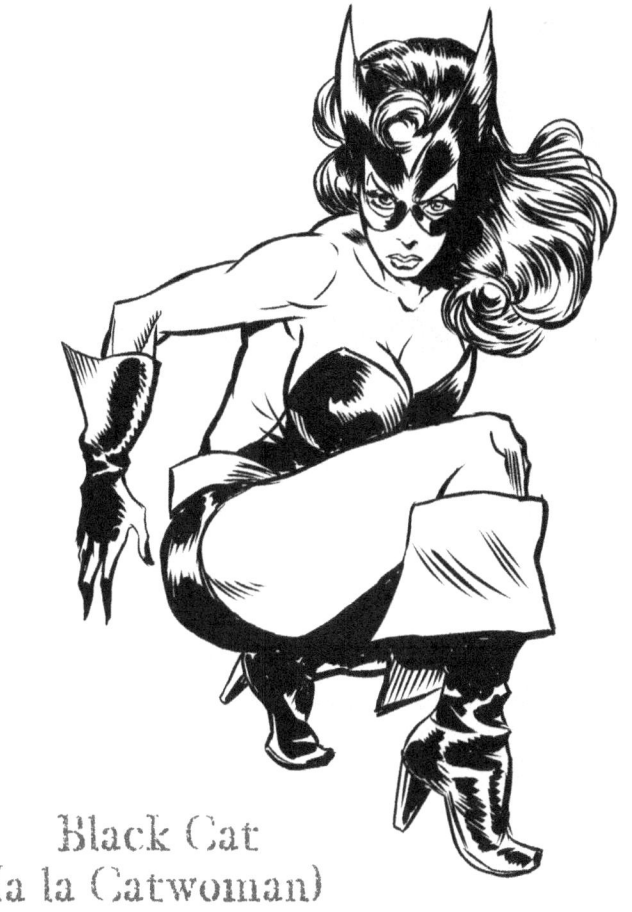

Black Cat
(a la Catwoman)

Harvey

Wondeman &
Friends

Nedor

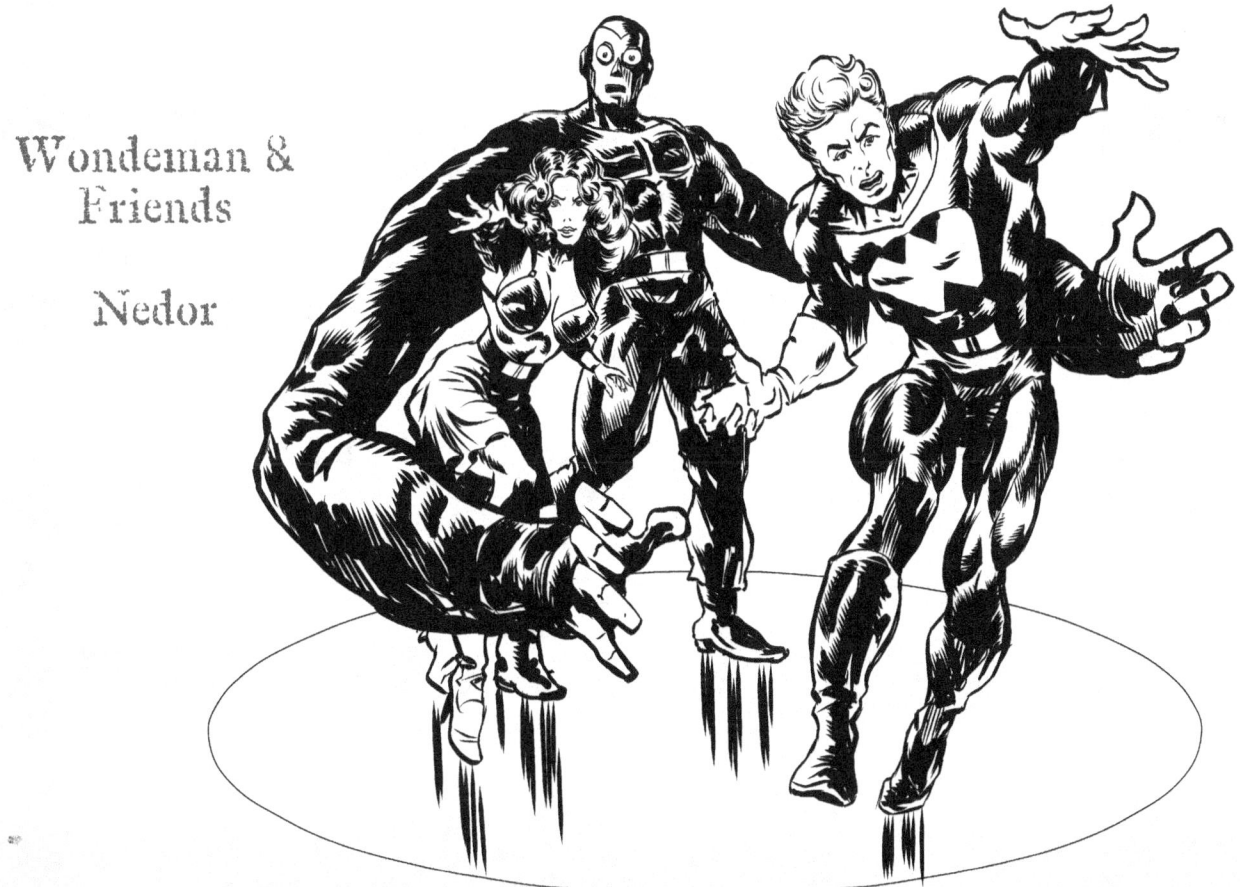

Fumetti

Sergio Bonelli is the most important Italian comic book publisher.
He created internationally famous characters like Dylan Dog, Martin Mystere, Tex and Zagor
(my favorite of all times).

He also developed a unique format for black and white "Fumetti" that greatly differs from the typical American comics.

As many other Italian would-be artists, I tested my luck against his...

In the next pages you will find my attempts at Bonelli's characters.

Since some of the sketches come from an early period of my artistic career, they are roughly done,...

Please do not judge me too hard, just enjoy my enthusiasm and passion for the traditional sequential art of the Bel Paese...

West, horros, sci-fi, the Italian way

In the following pages, you can find my test assignments for Italian comics publisher Sergio Bonelli.

I worked hard, but unfortunately, I was unsuccessful...

They are from my very early days, so, please, do not mind if they are a bit rough around the edge...

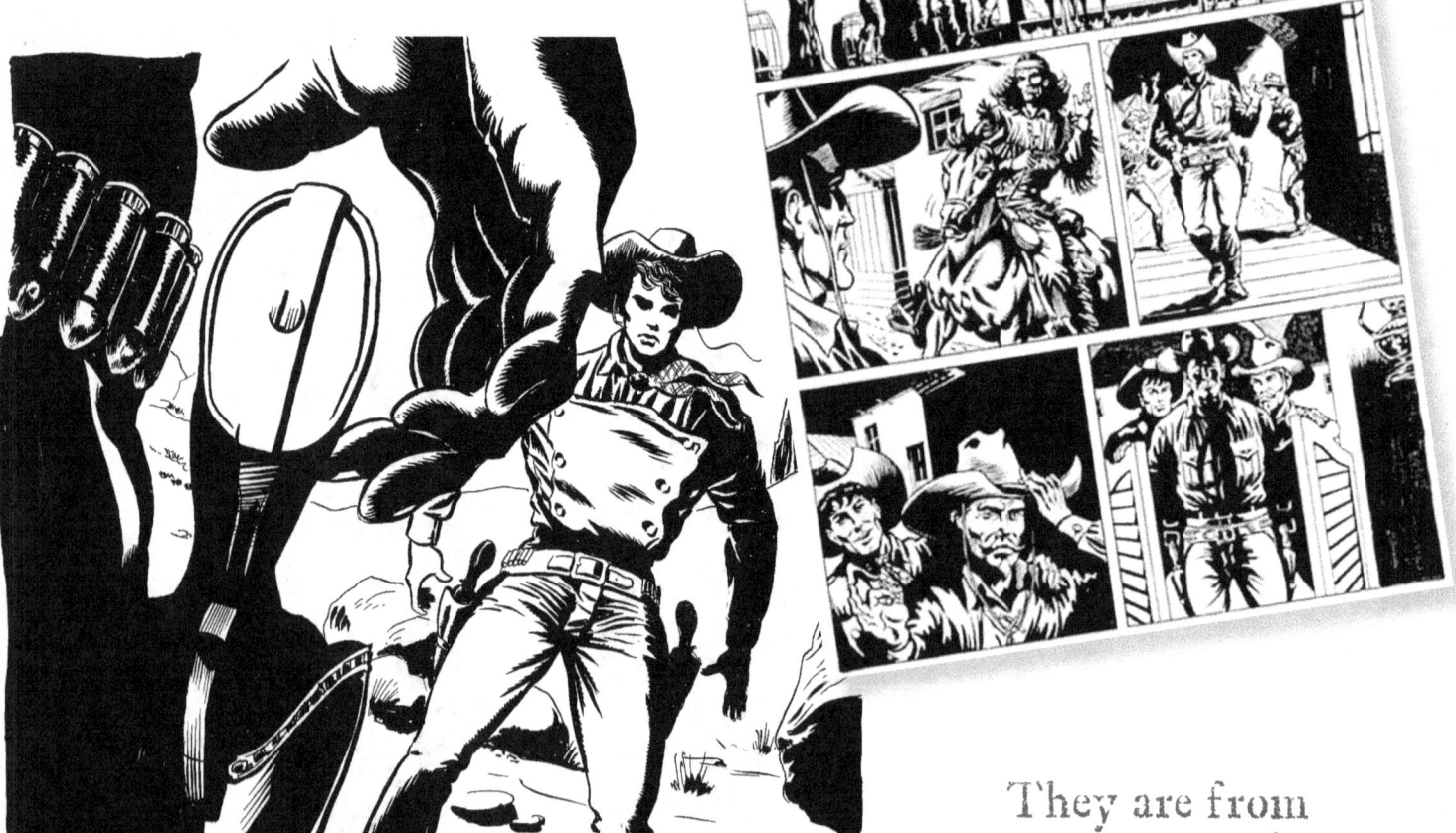

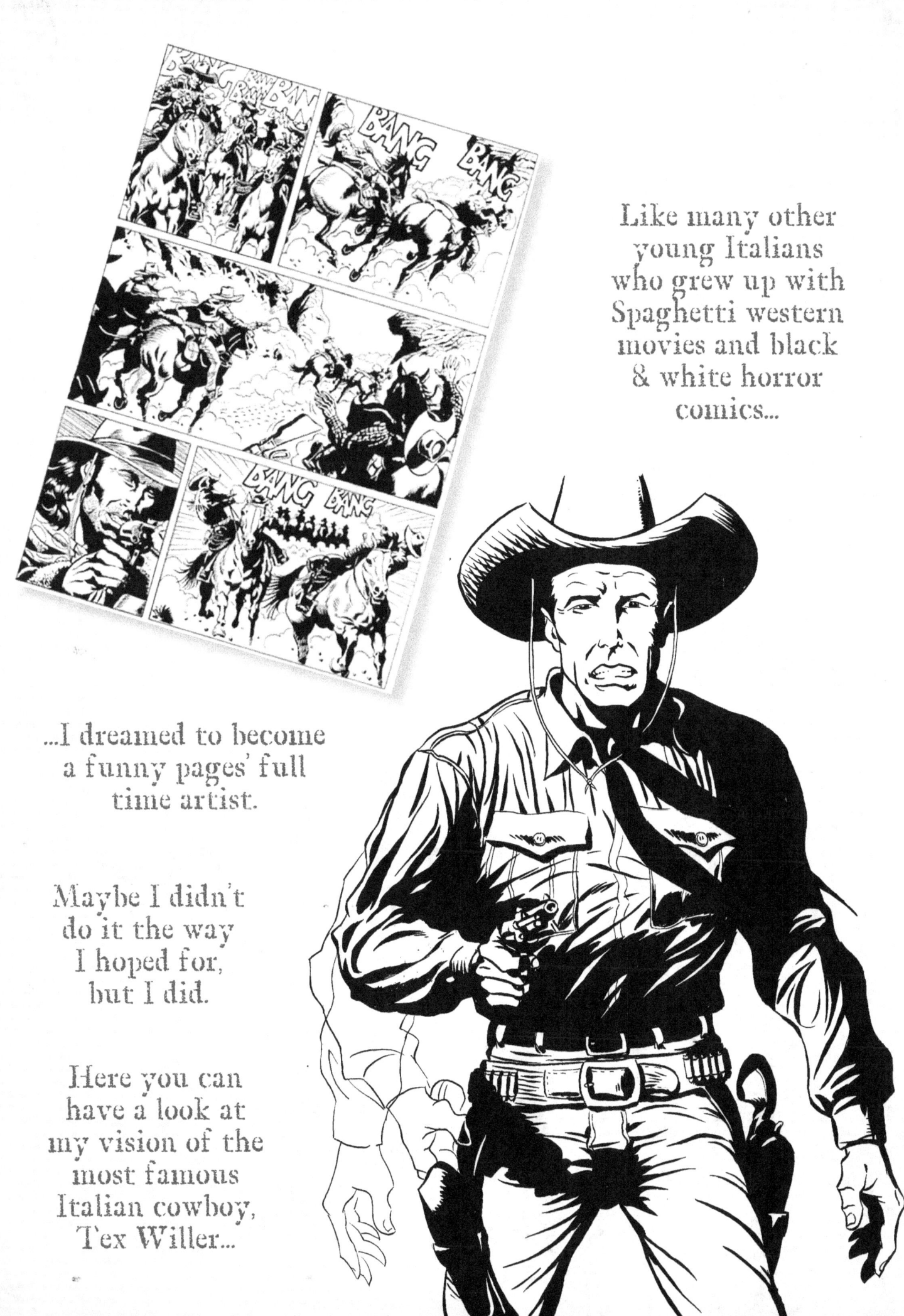

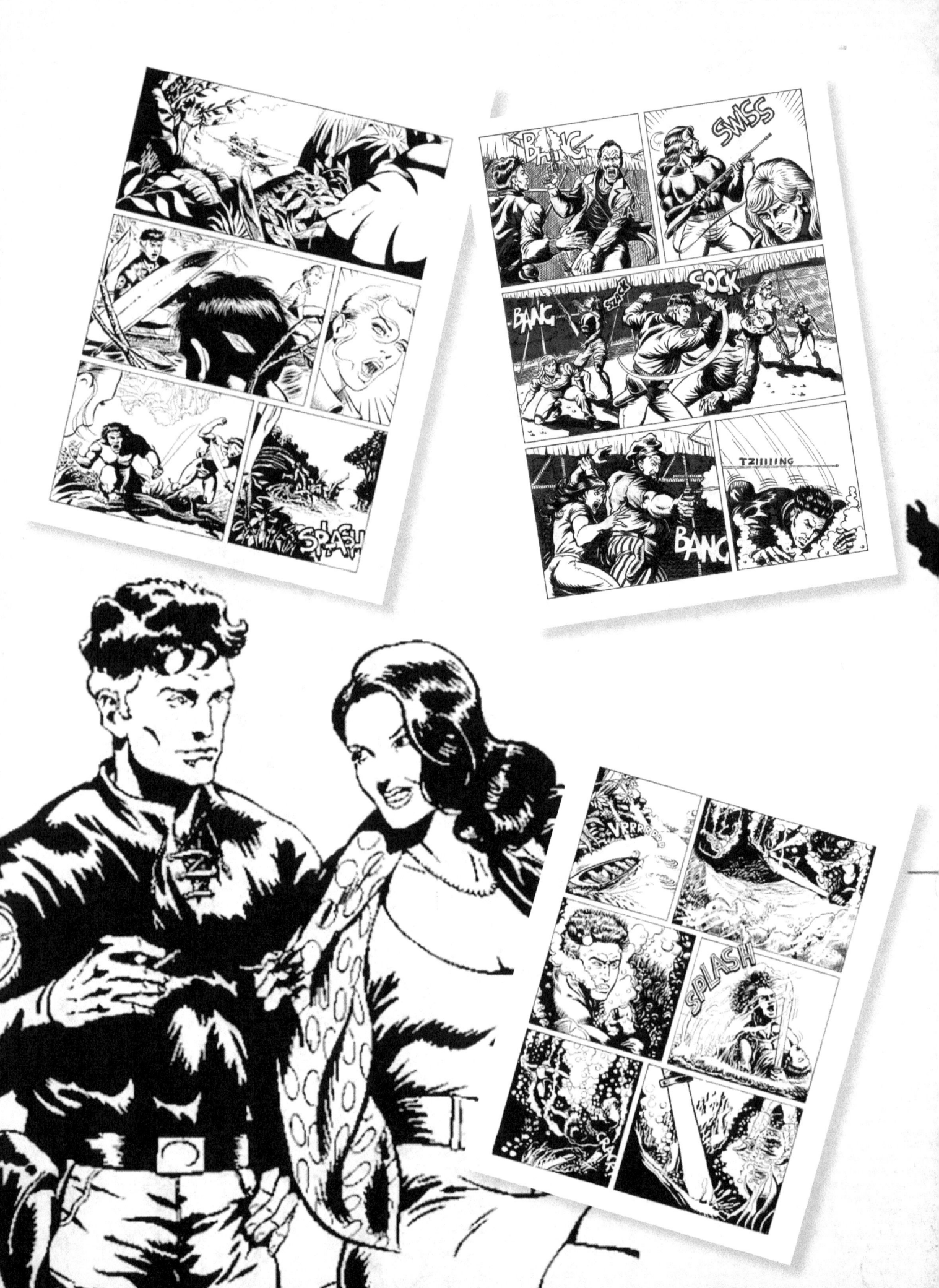

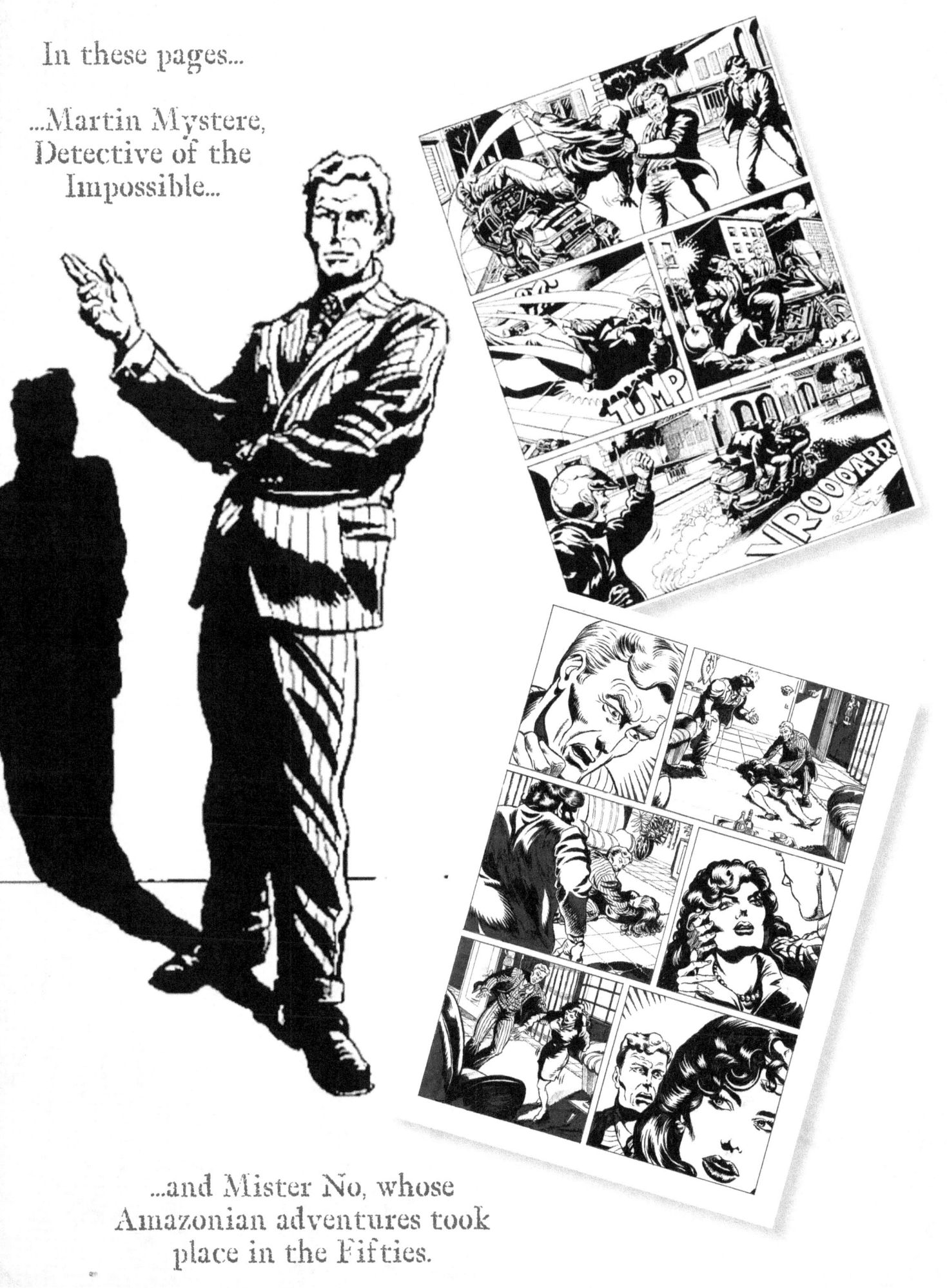

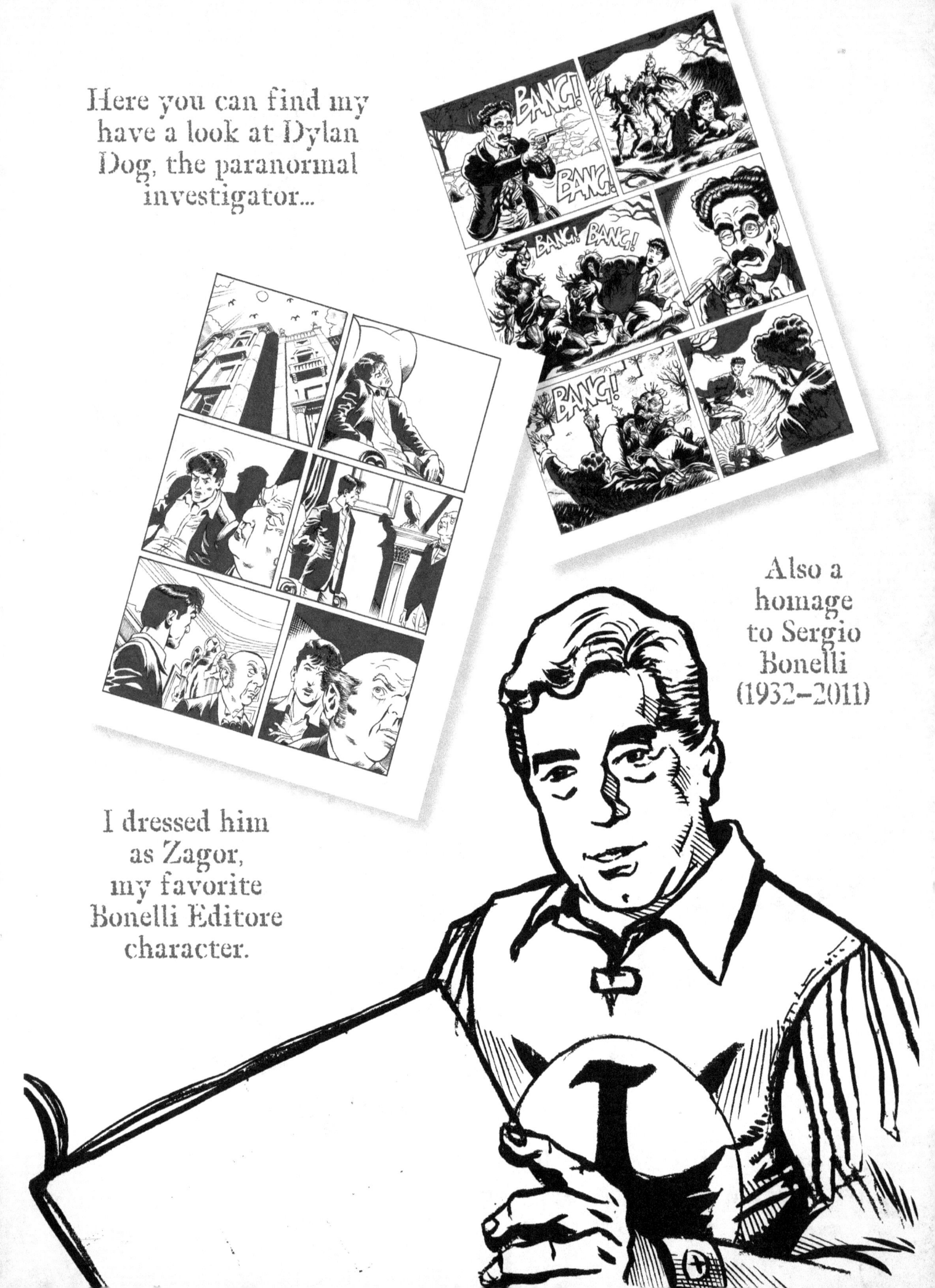

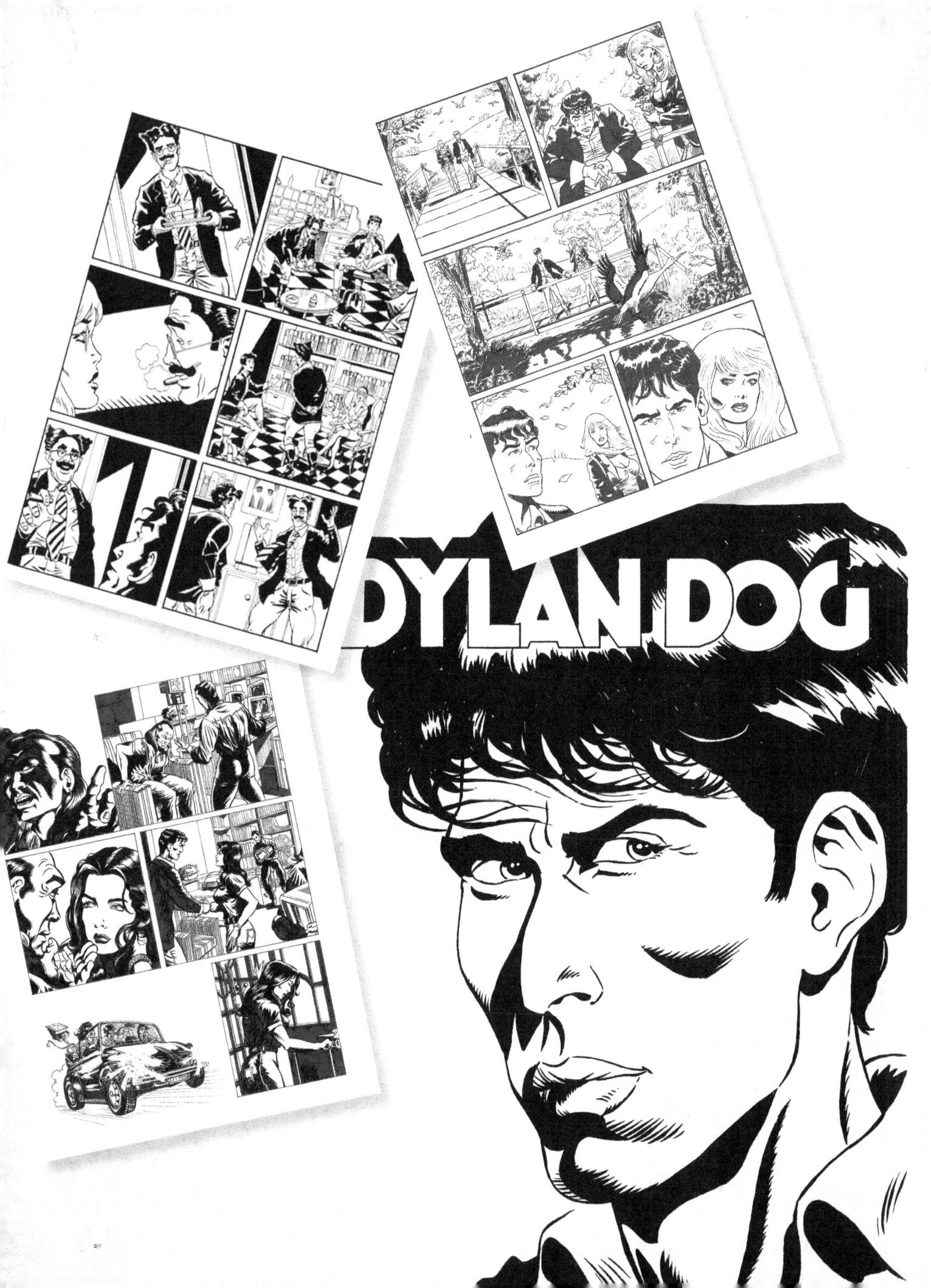

Here my interpretation of John Doe, from Eura Editoriale.

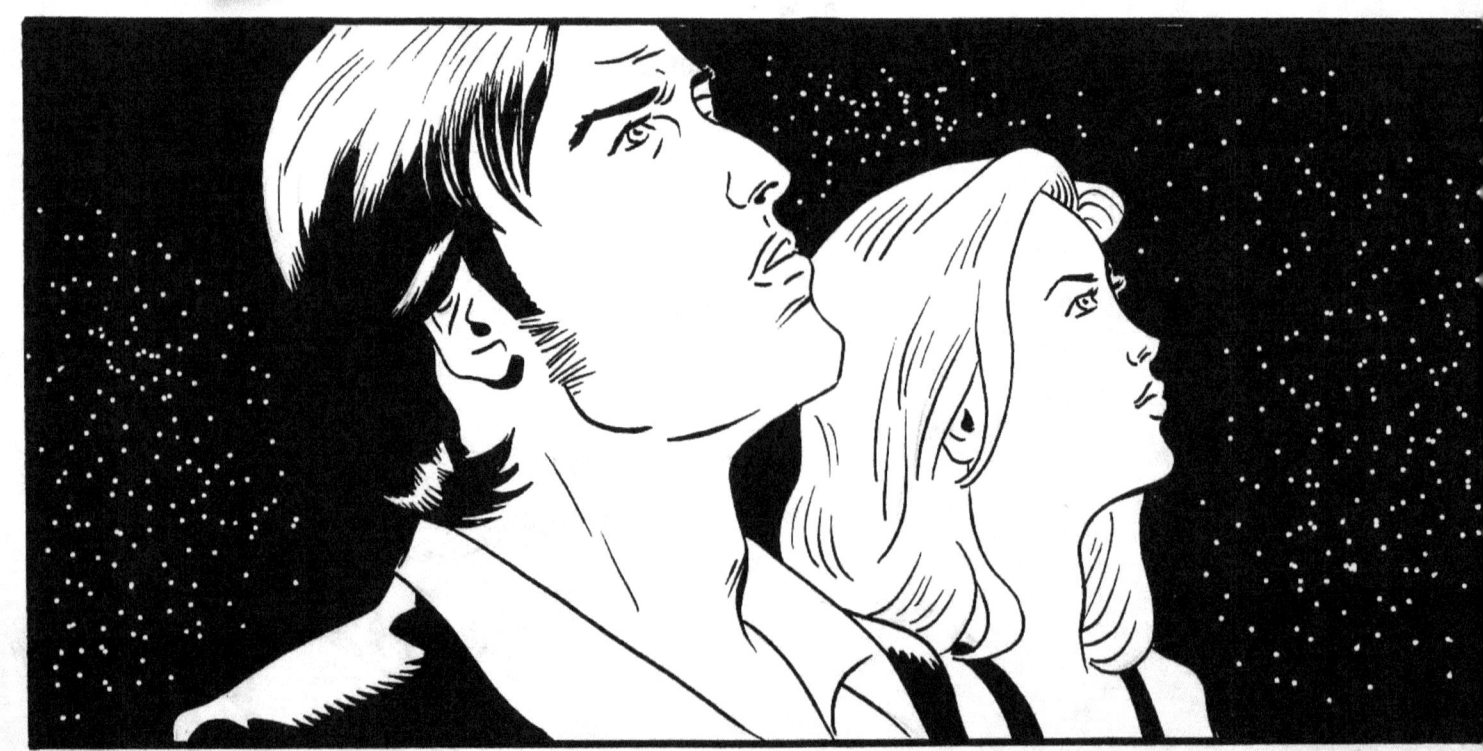

... John is a death dealer working for "Trapassati" Inc.

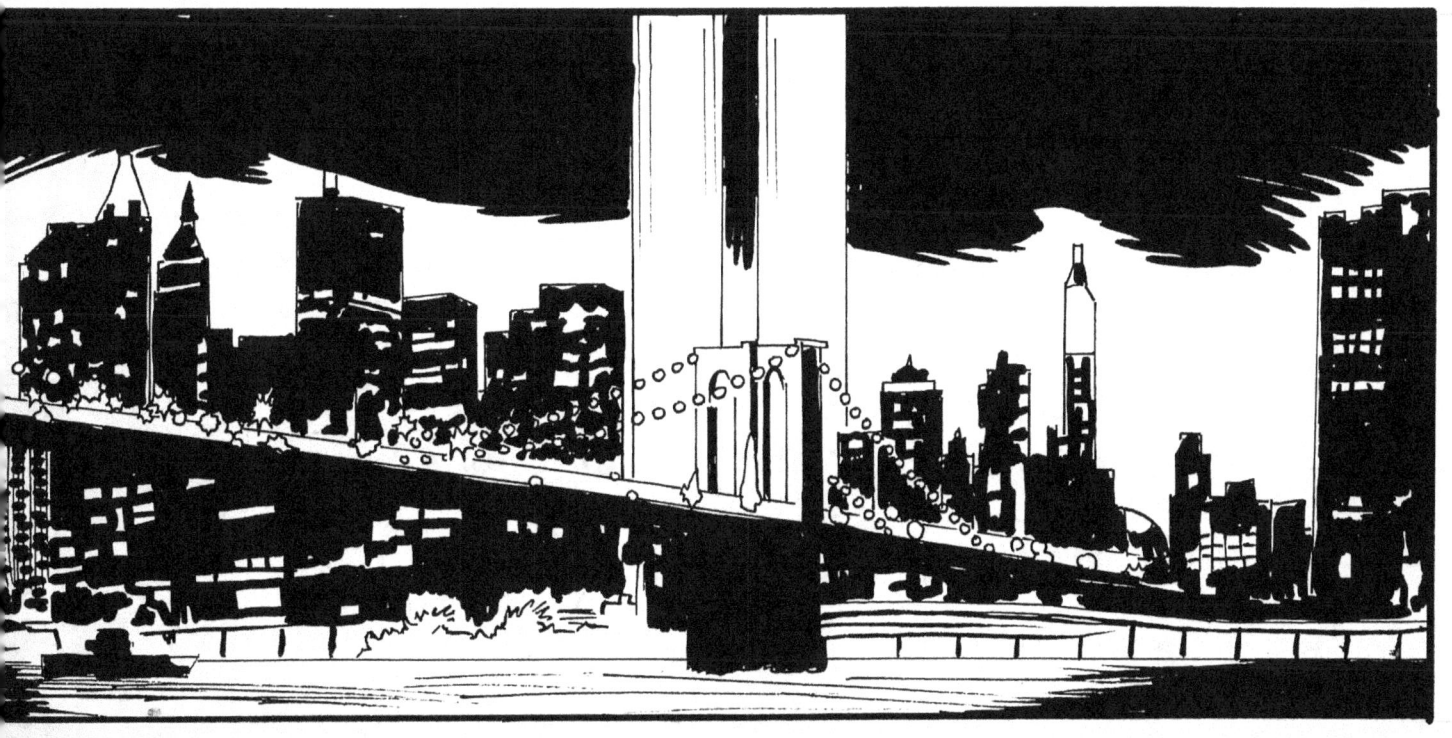

Literature

I am not sure how to approach this section...
The editor wanted to add the "good art" that would fit in books...

"go again through your sketchbook," I have been told "I am sure you will dig out some more things from you past and present!"

I am a comely person, so I did exactly what I was told.

It took me a day and a night. My wife was not very happy to find half inked drawings all around the house.

She shaked her head with disappointment, but, in the end, she helped me bring order to my chaos.
As usual.

In the following pages, you will find mixed art inspired by E.R. Burroughs' books.

A selection of artwork dedicated to Emilio Salgari (a springroll of Burroughs and R.E. Howard in Italian sauce), creator of several adventure sagas: the Sandokan and the Pirates of the Malaysia, the Pirates of the Antilles and the Corsairs of the Bermuda, just to mention a few.

Also, studies of female warriors I did after reading Conan the Barbarian comics and short stories.
I have always been in love with Belit, but don't tell my wife...

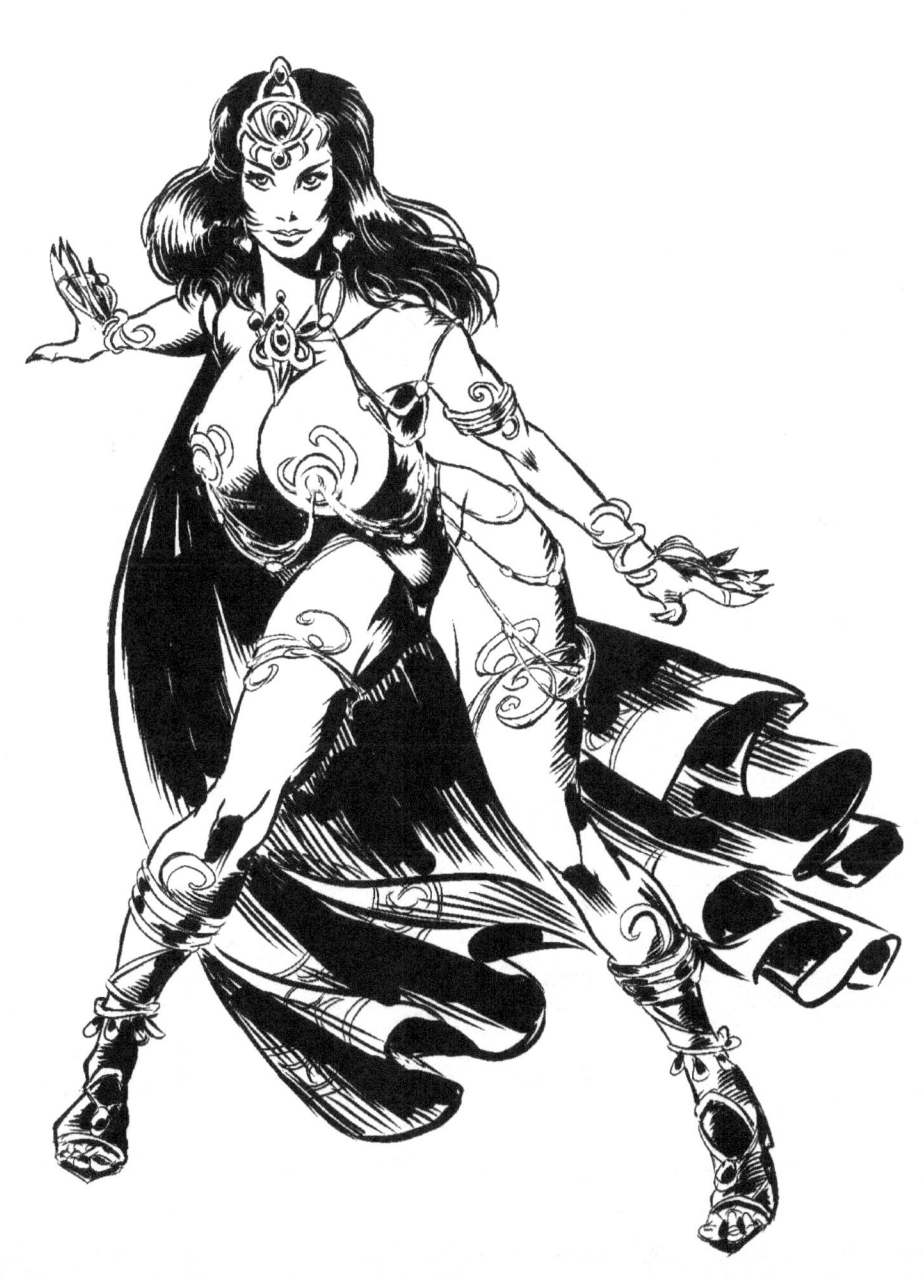

Burroughs' Mars

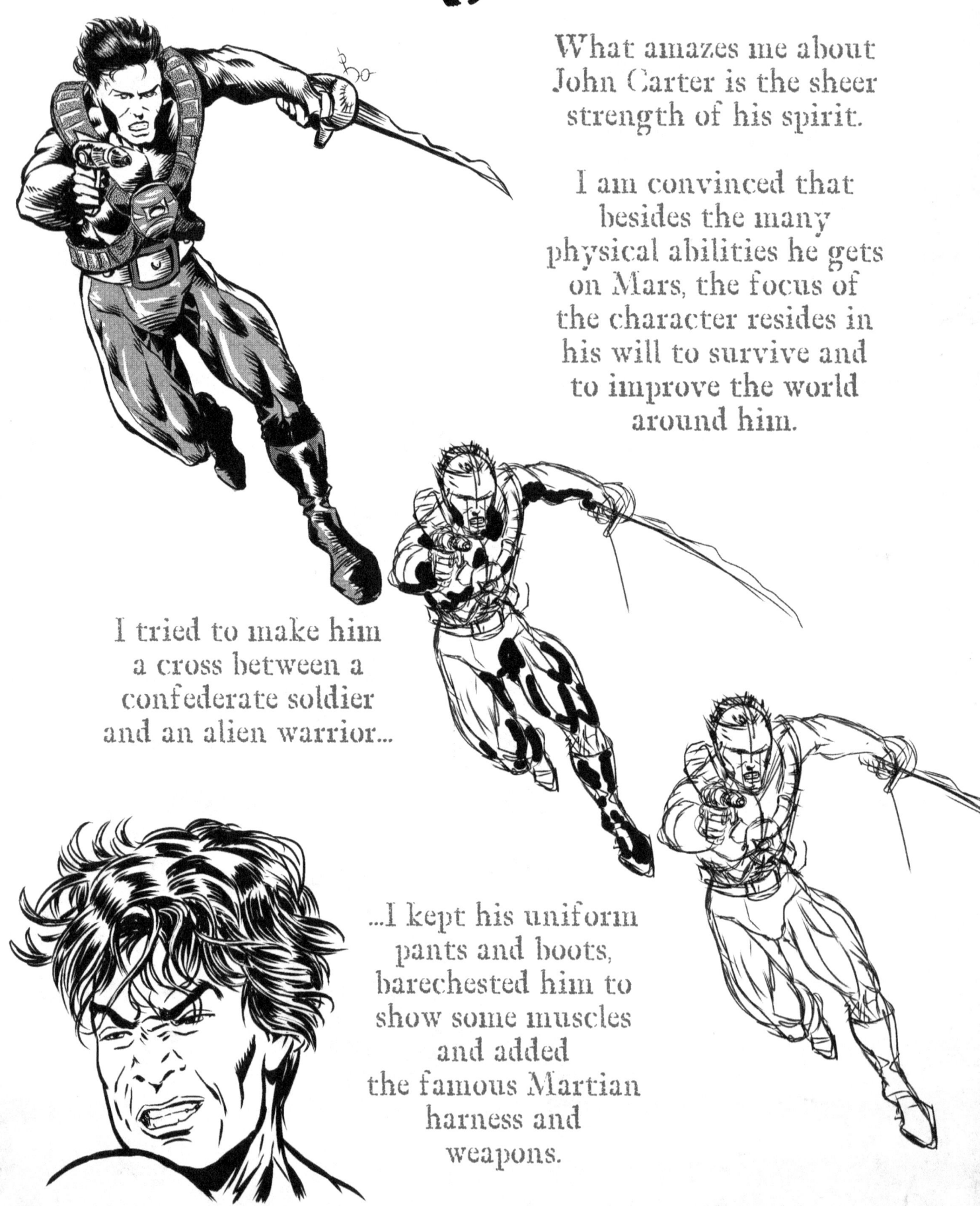

What amazes me about John Carter is the sheer strength of his spirit.

I am convinced that besides the many physical abilities he gets on Mars, the focus of the character resides in his will to survive and to improve the world around him.

I tried to make him a cross between a confederate soldier and an alien warrior...

...I kept his uniform pants and boots, barechested him to show some muscles and added the famous Martian harness and weapons.

Martian women are beautiful, proud and almost unreachable, yet they had an inner fire that burns with unmeasurable passion.

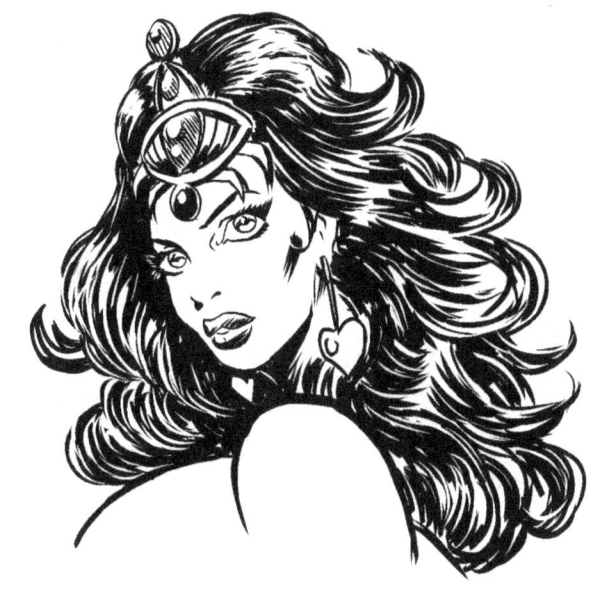

I tested myself with a Martian Princess.

Her garb leaves very little to the imagination...

...Mars is a hot planet after all...

Why Martian women got breasts if they all lay eggs is a mystery I was not able to unveil...

Not that I complain...

Monster galore from Mars...

Masenas,
the chameleonic Cat-Men
from Thuria,
the lush nearer moon...

Calot,
the terrible and adorable
Martian dog.
a ten-legged monster
as large as a pony.

The savage Green Martians
from the endless sands of
the Souther Hemisphere of
Barsoom.

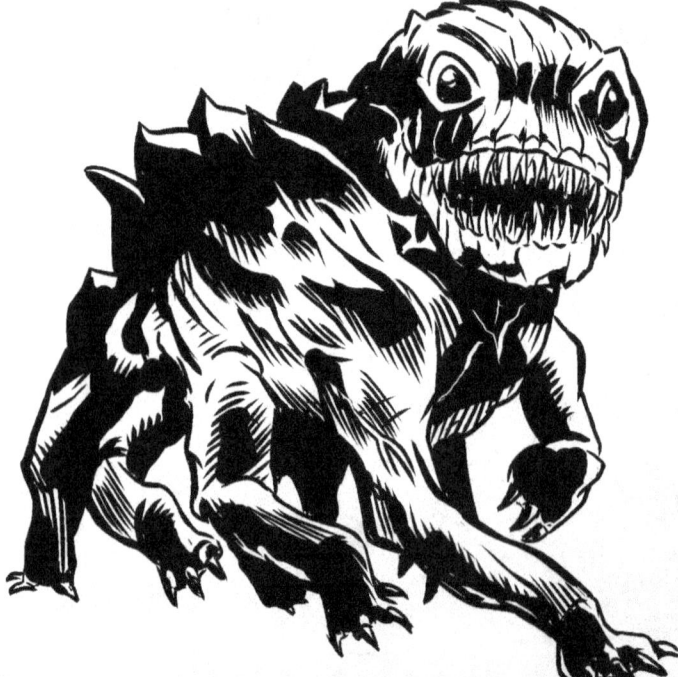

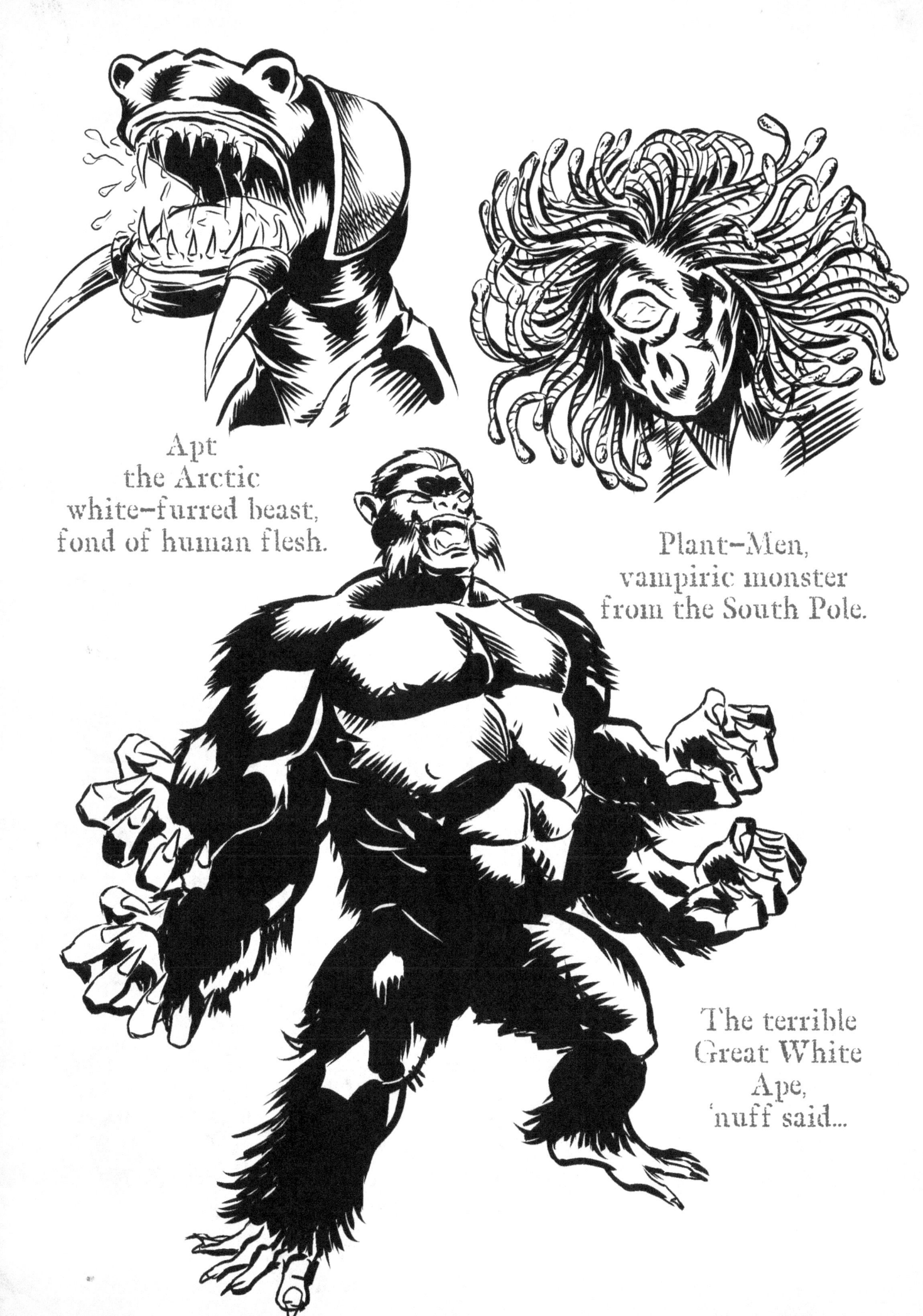

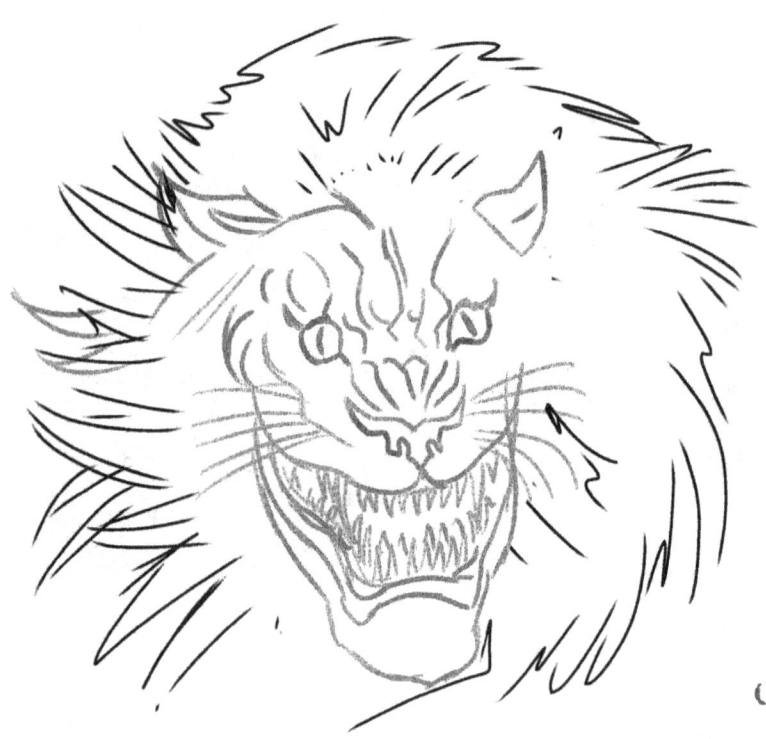

The Martian lion, called Banth, is probably the most famous wild beast of Mars...

A ten-legged killing machine that roams the shores of the Martian dead seas...

The real challenge here was not to draw a lion that just looked alien.

It was to create an outwardly monster with a different physical built, while preserving Burrough's description...

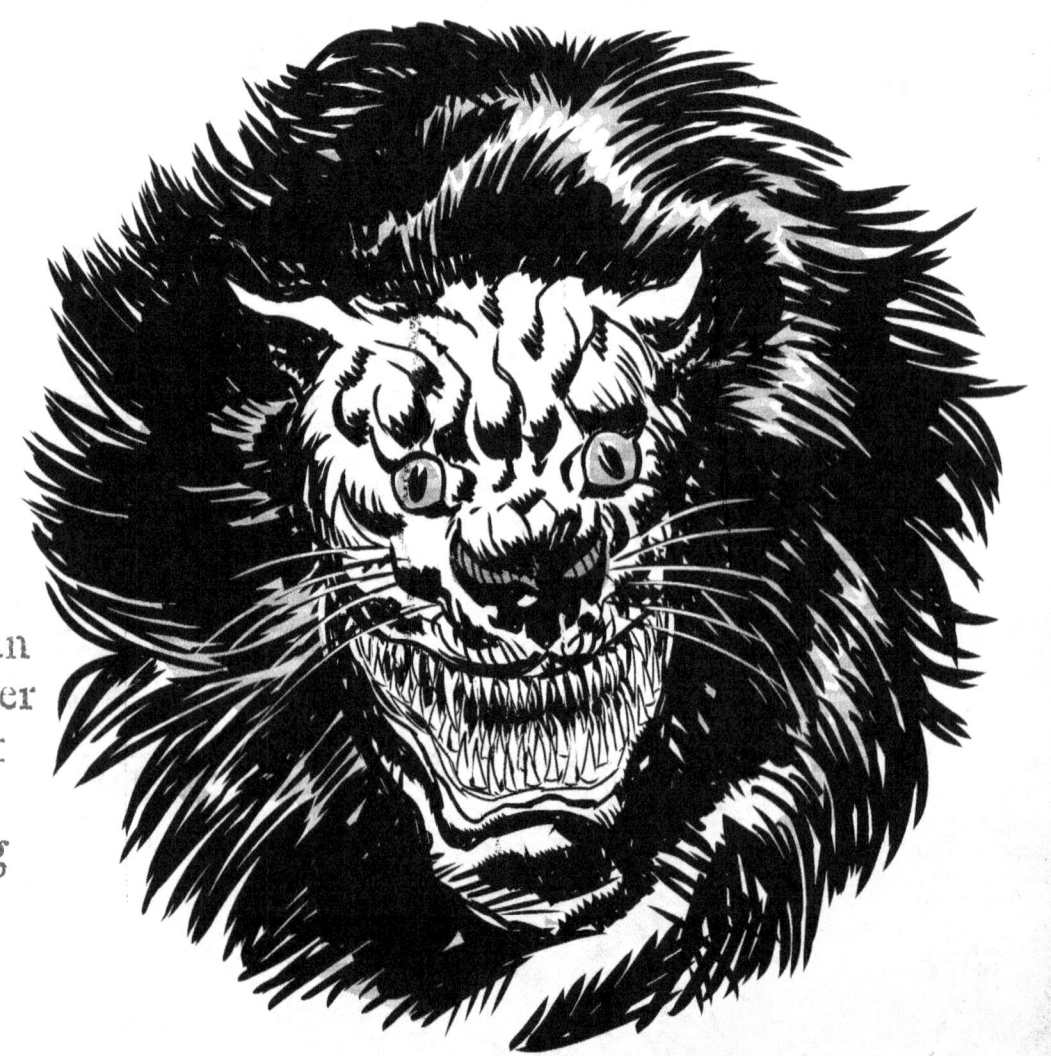

Sketches and revisions....

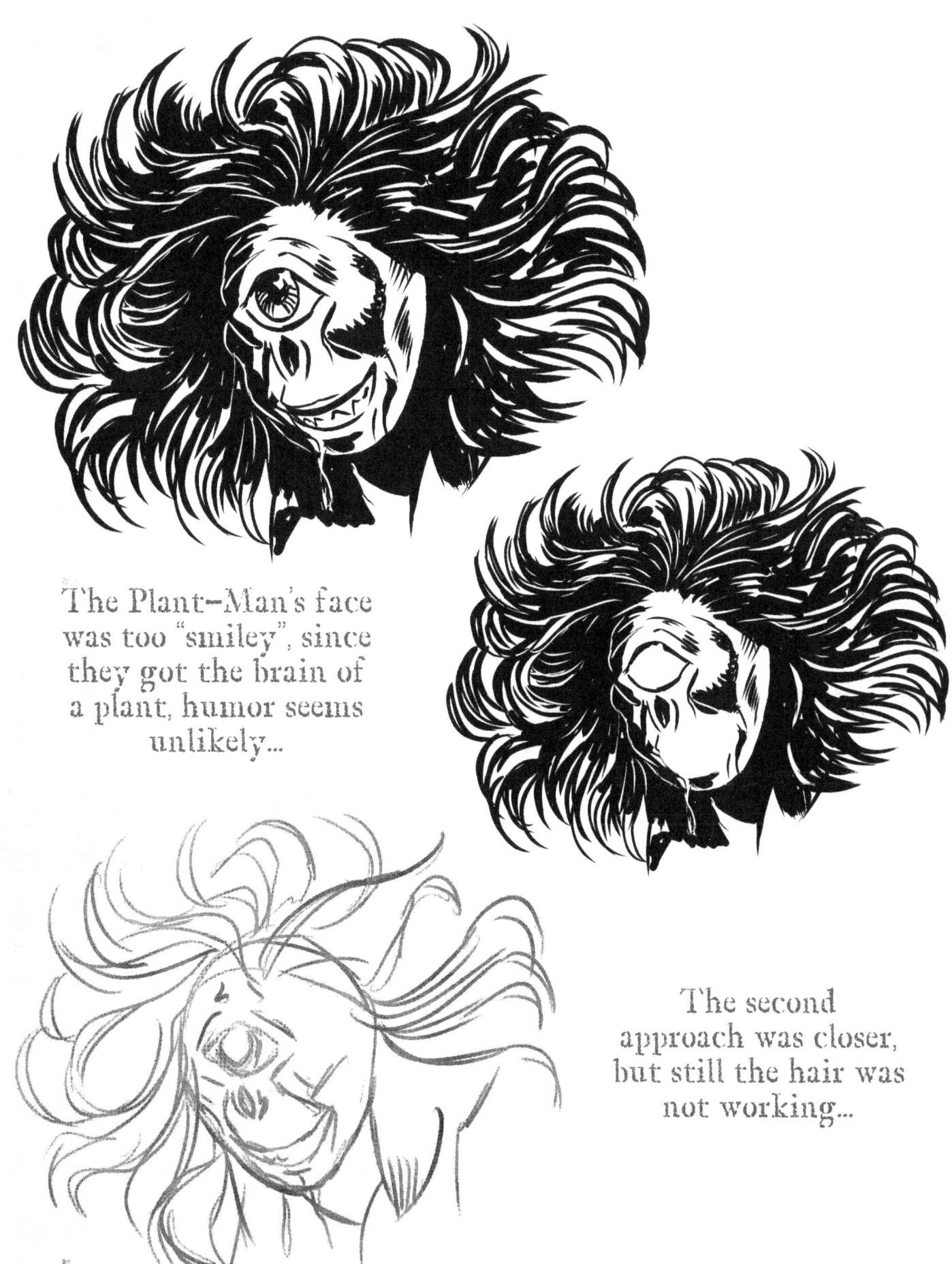

The Plant-Man's face was too "smiley", since they got the brain of a plant, humor seems unlikely...

The second approach was closer, but still the hair was not working...

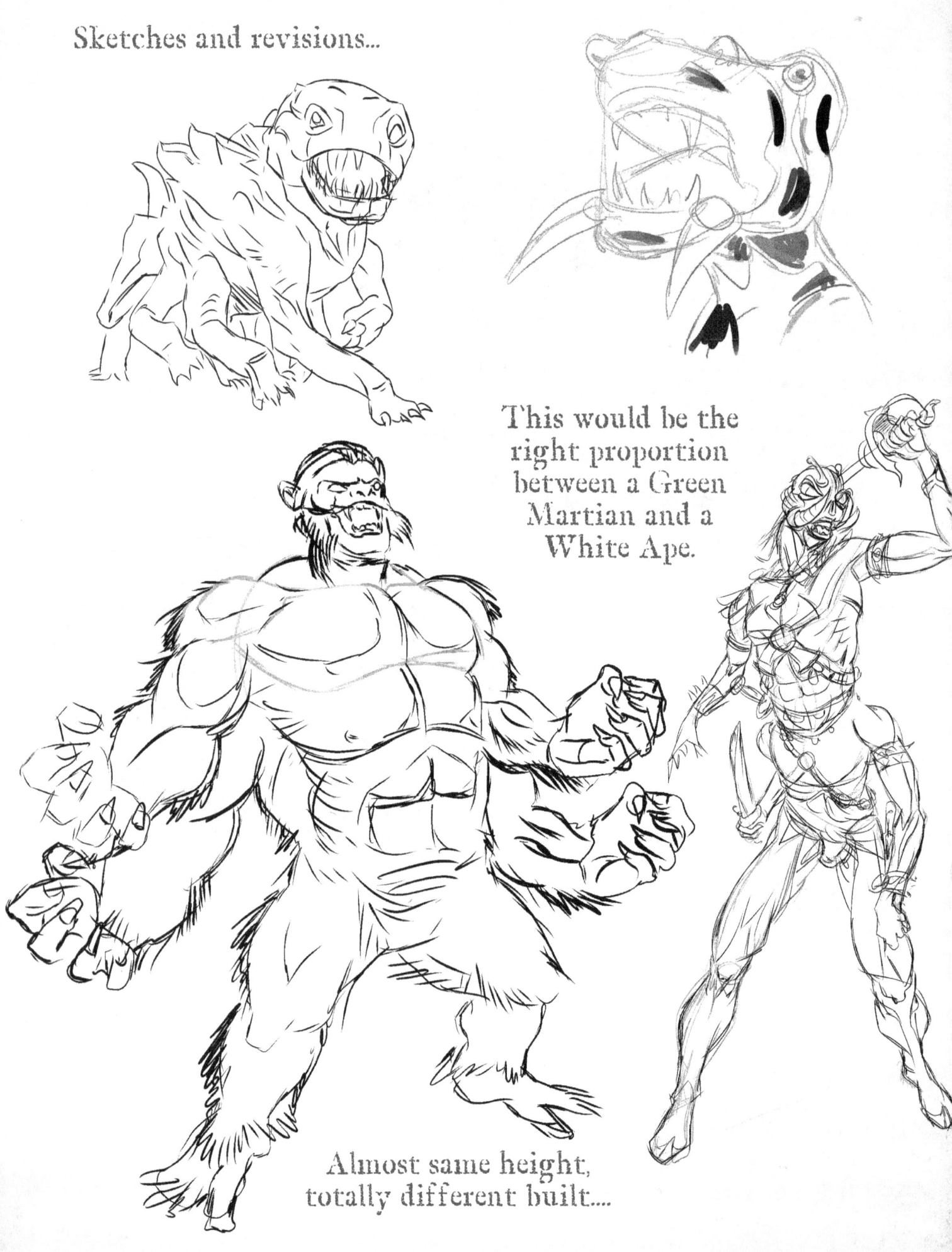

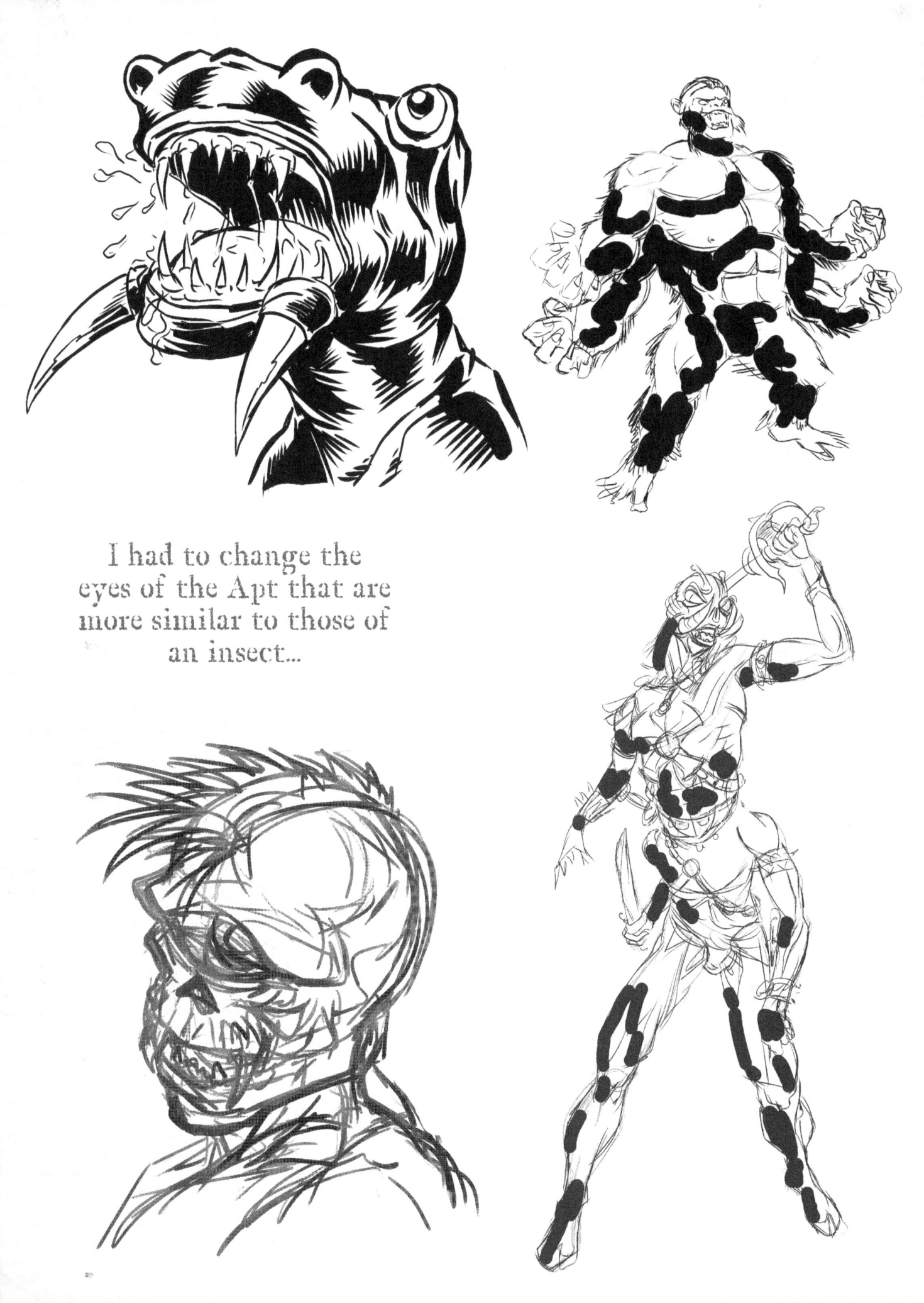

I had to change the eyes of the Apt that are more similar to those of an insect...

Carson of Venus

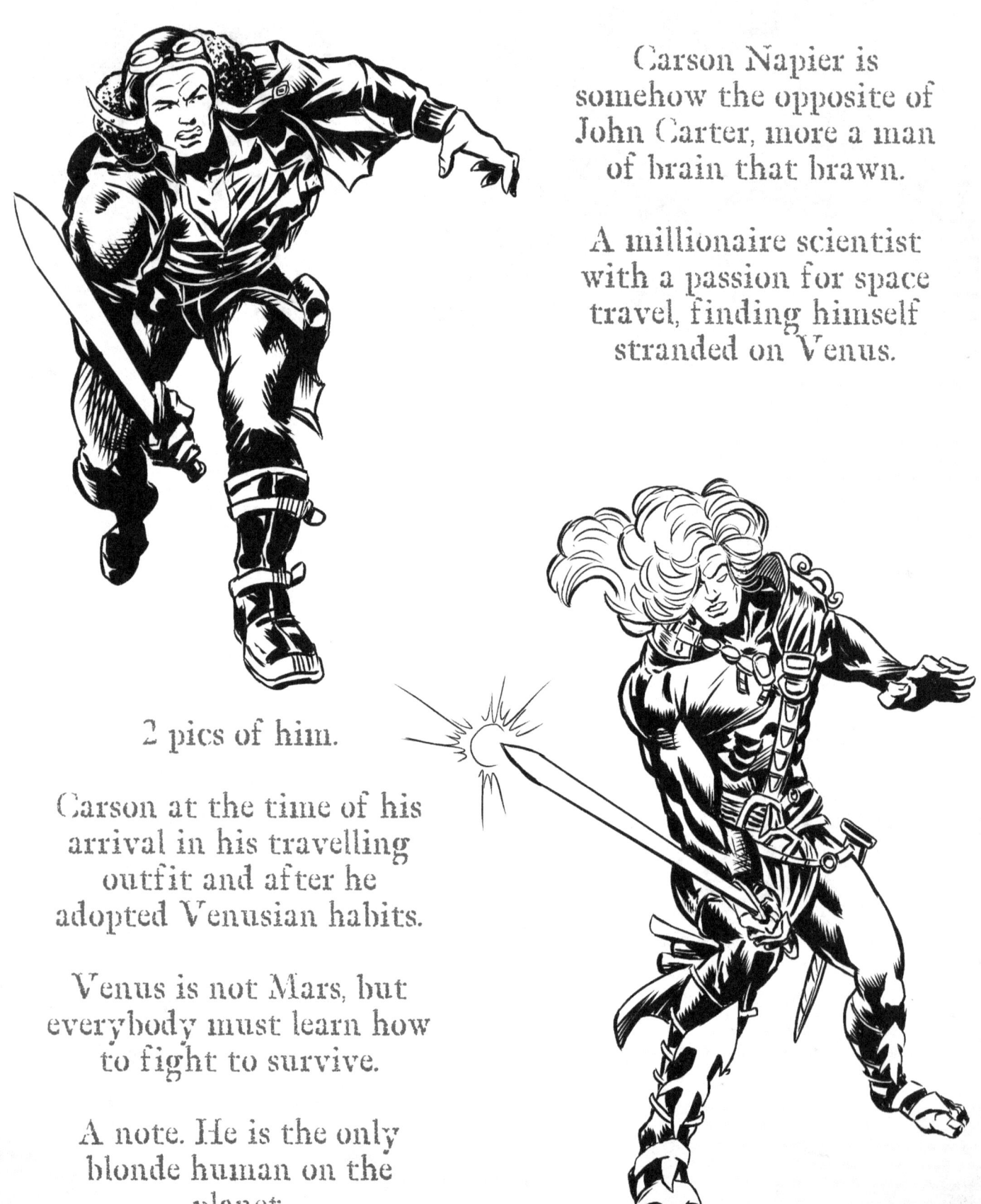

Carson Napier is somehow the opposite of John Carter, more a man of brain that brawn.

A millionaire scientist with a passion for space travel, finding himself stranded on Venus.

2 pics of him.

Carson at the time of his arrival in his travelling outfit and after he adopted Venusian habits.

Venus is not Mars, but everybody must learn how to fight to survive.

A note. He is the only blonde human on the planet.

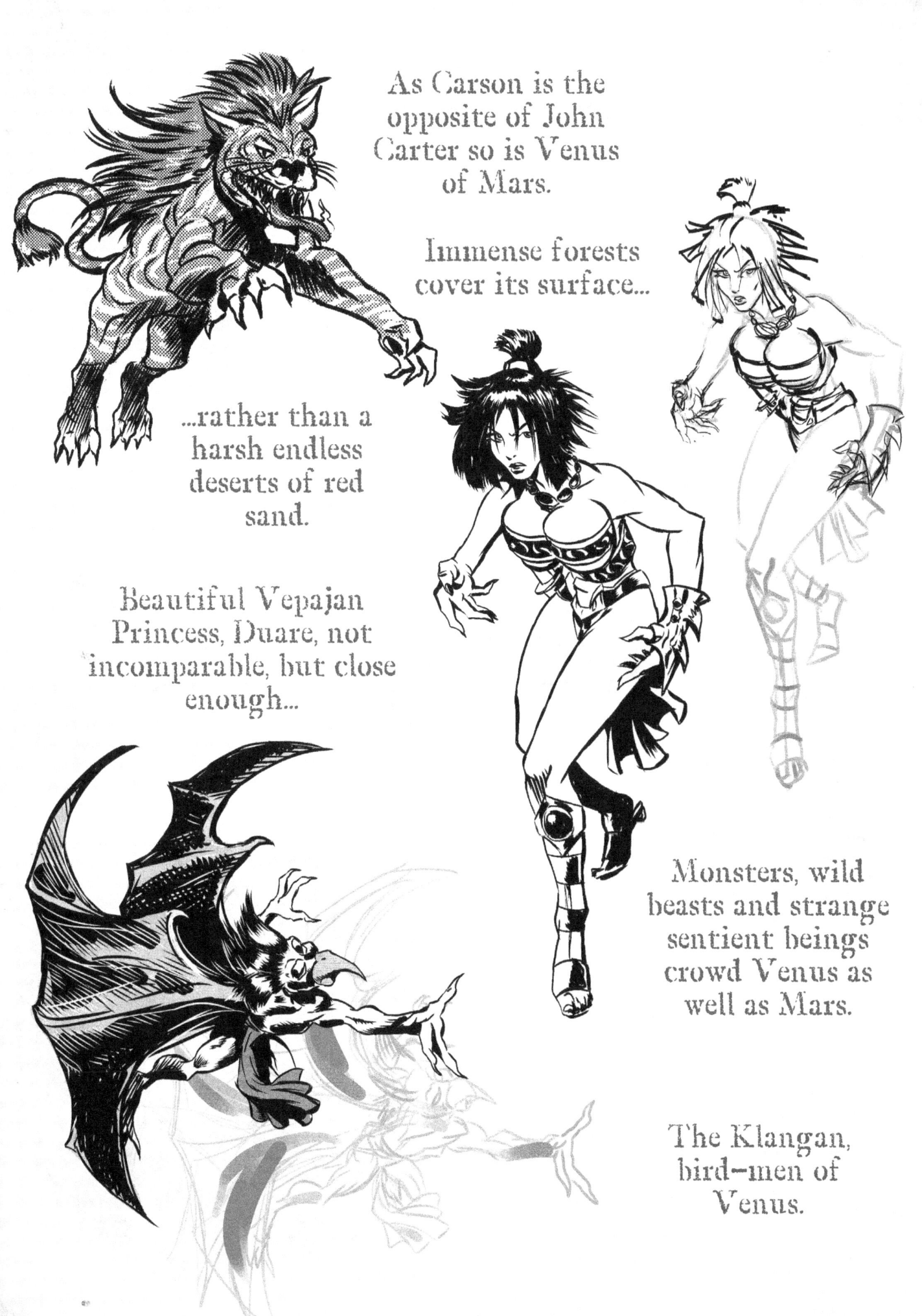

Savages

La of Opar was always an inspiration.

Queen and High Priestess of a lost Atlantean colony, located in the deep jungles of Africa...

...she is a beautiful and fierce woman capable of intense love and burning hatred.

The real challenge about her was to depict her barbarian beauty and unrestrained womanhood.

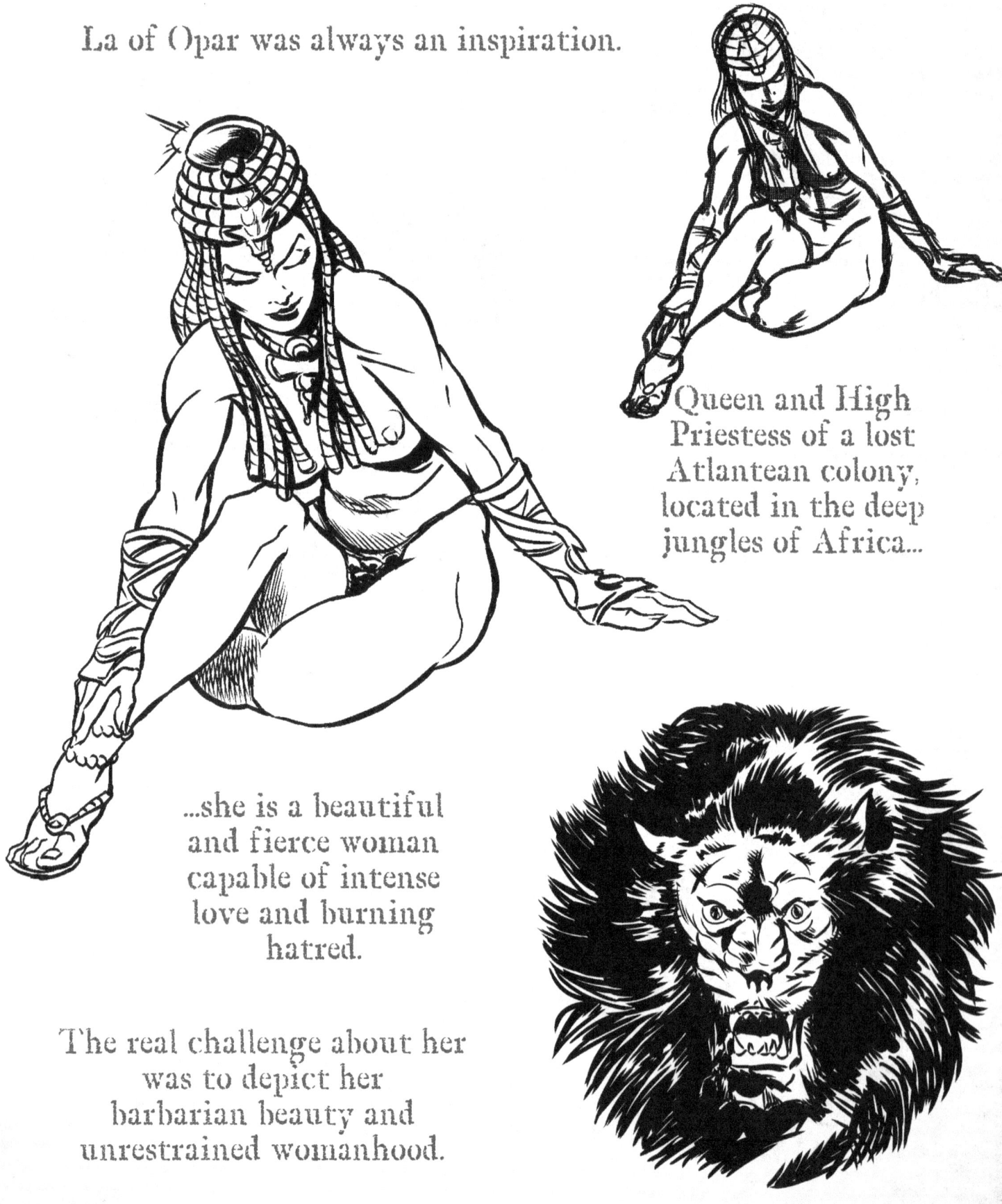

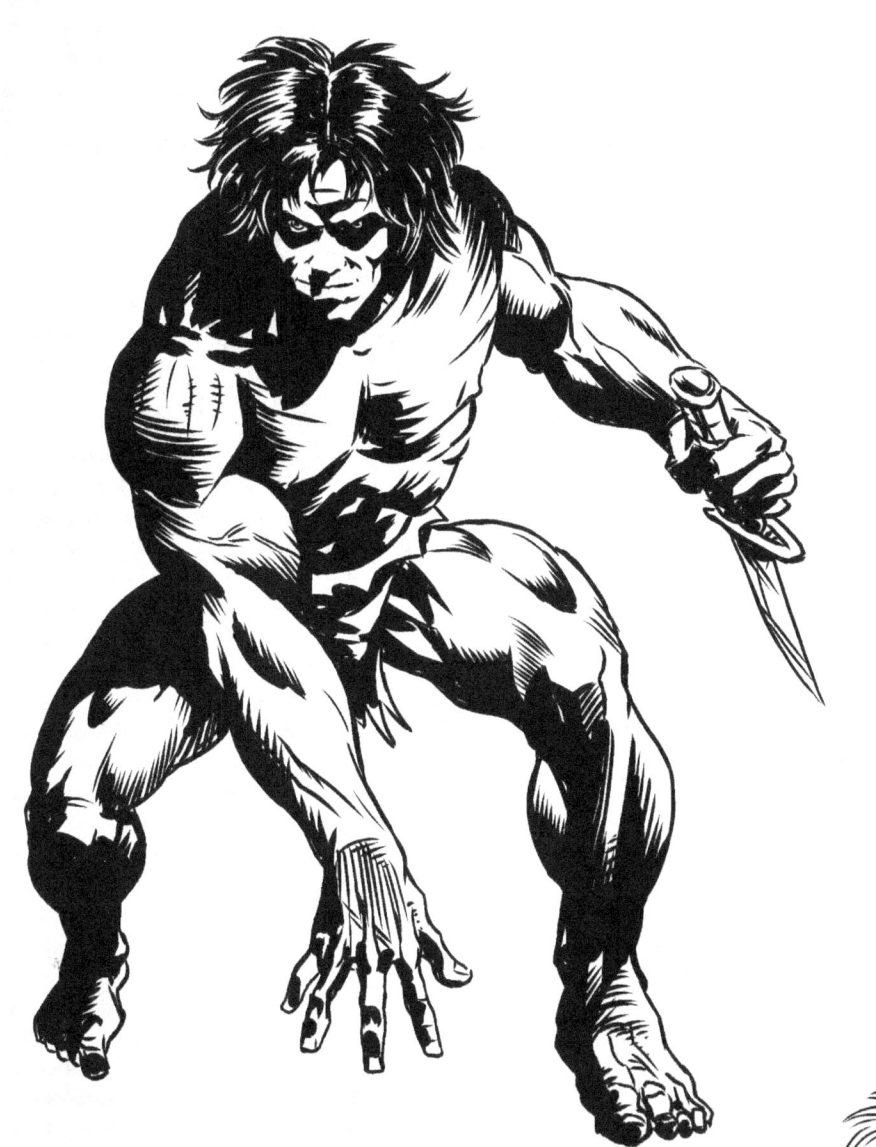

Since the Oparians suffer of extreme sexual dimorphism, with almost perfect females and beastly males La falls in love with everybody favorite man-ape, Tarzan...

...as Tarzan spurns her advances, she comes close to sacrifice him to the Flaming God, worshipped by the Oparians.

Tarzan and La meets several times through the saga, often with explosive results!

Barbarians

Heroic fantasy barbarians have always fascinated me.

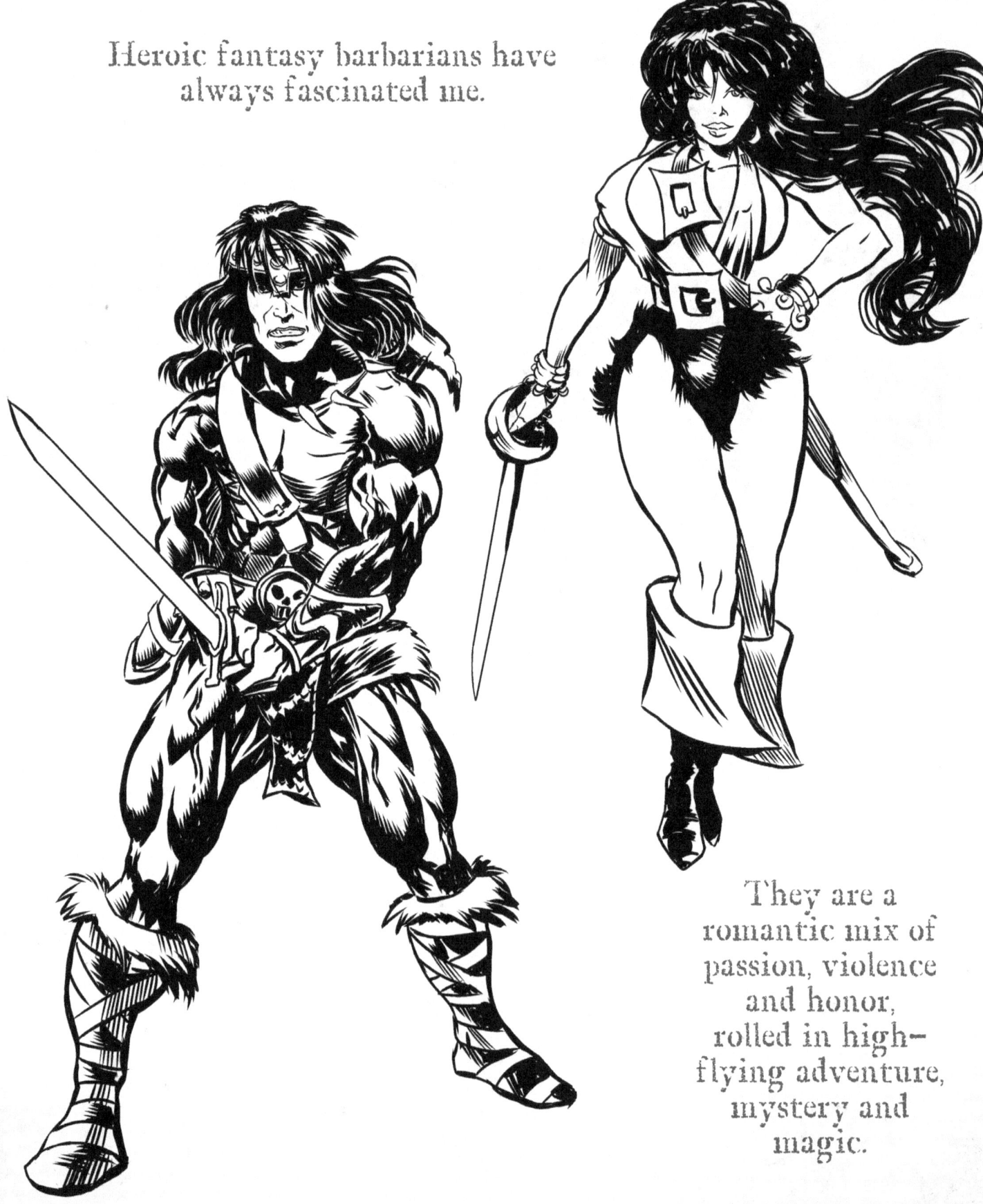

They are a romantic mix of passion, violence and honor, rolled in high-flying adventure, mystery and magic.

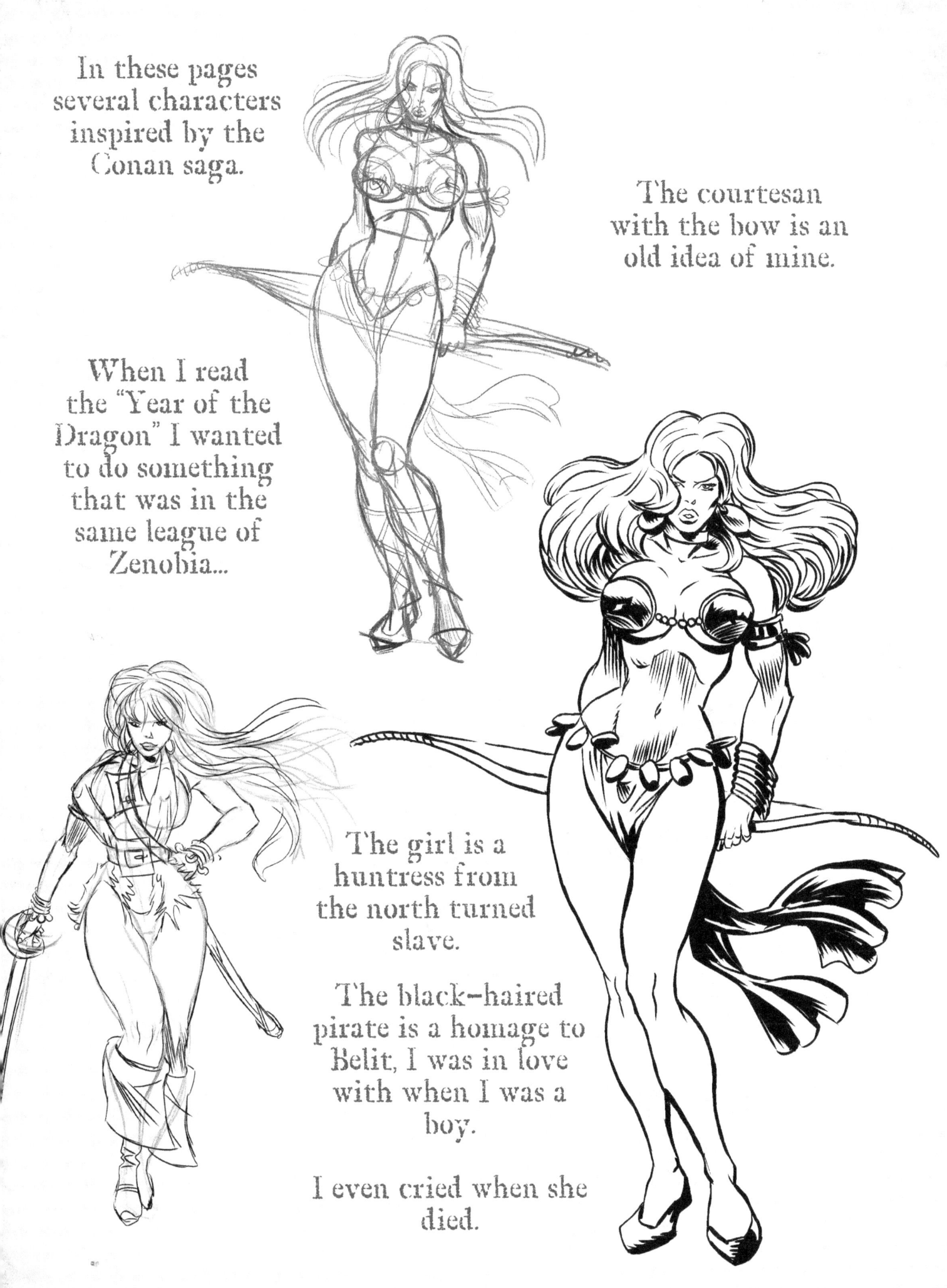

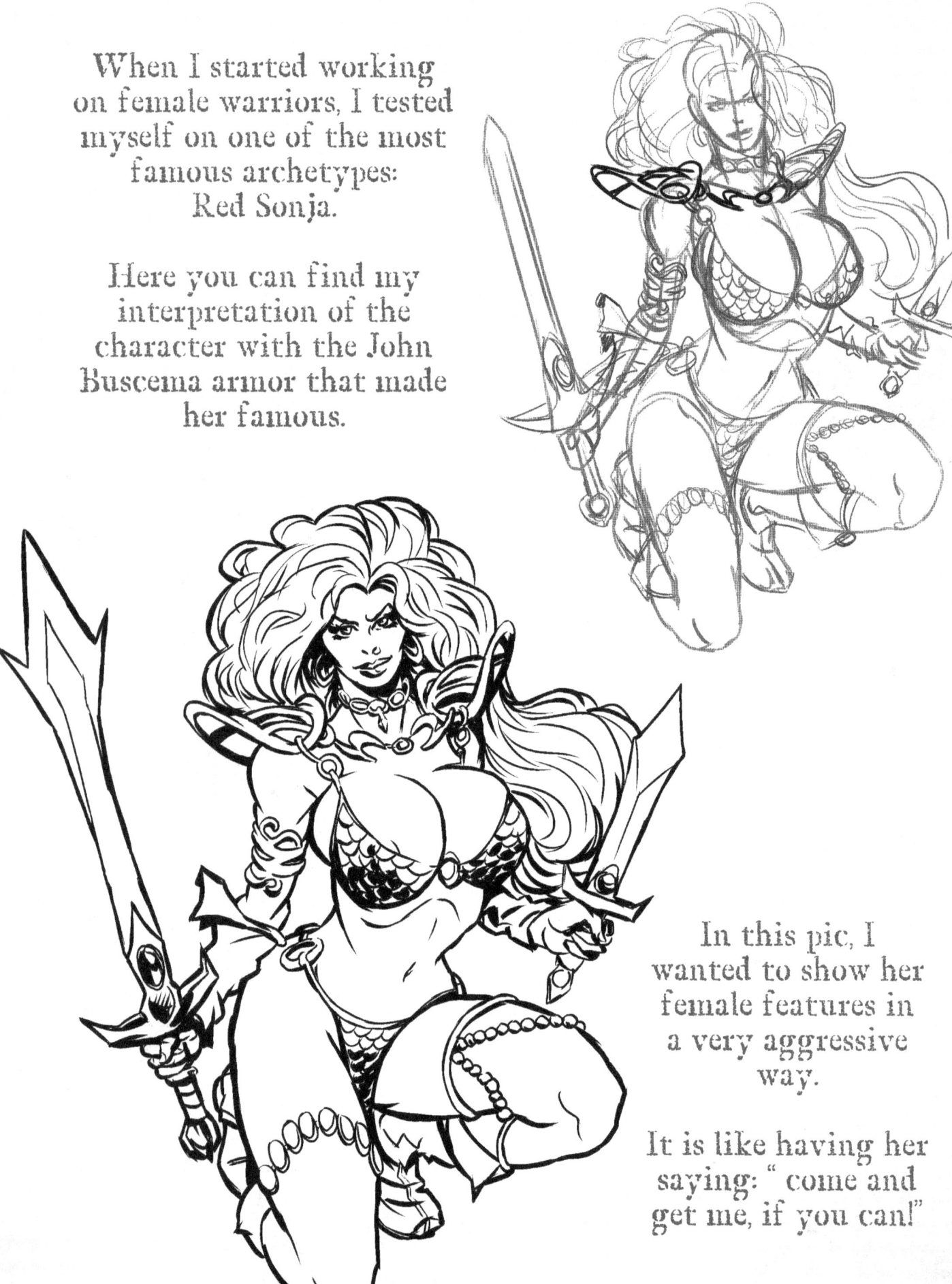

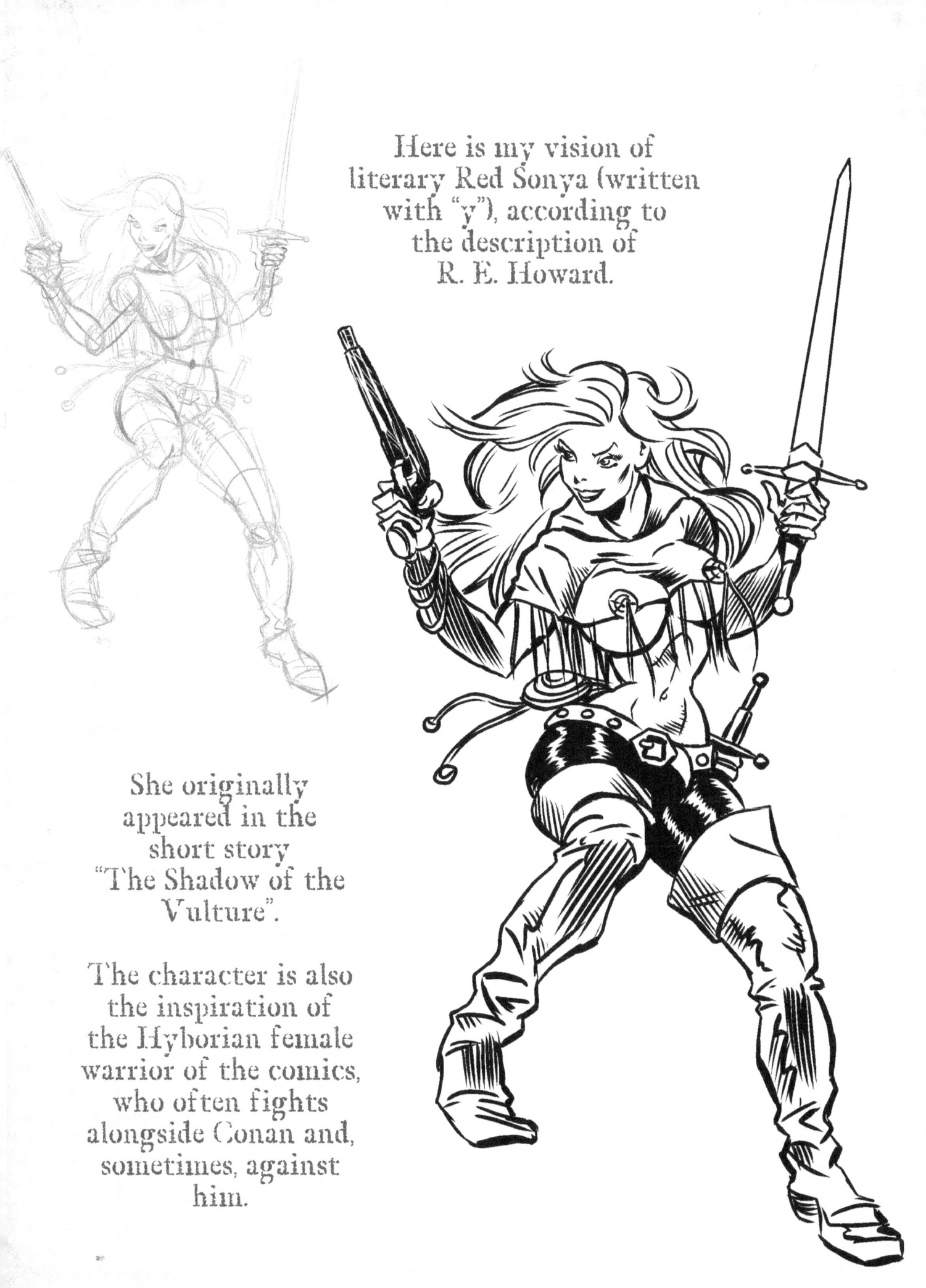

Salgari

The life of Emilio Salgari is that of many Italians...

...a tremendous talent with no money in his pocket.

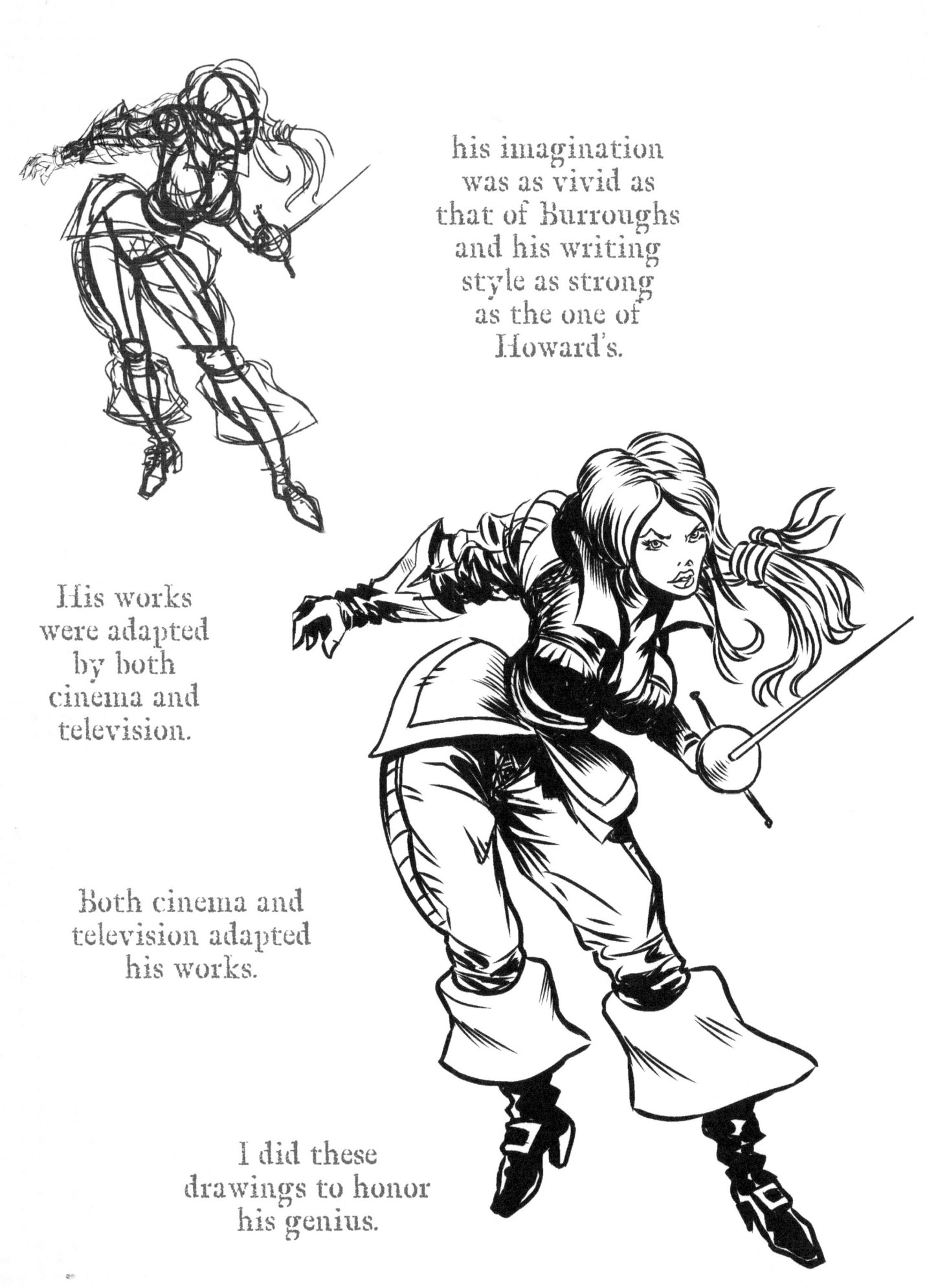

his imagination was as vivid as that of Burroughs and his writing style as strong as the one of Howard's.

His works were adapted by both cinema and television.

Both cinema and television adapted his works.

I did these drawings to honor his genius.

Sullivan comic book #0

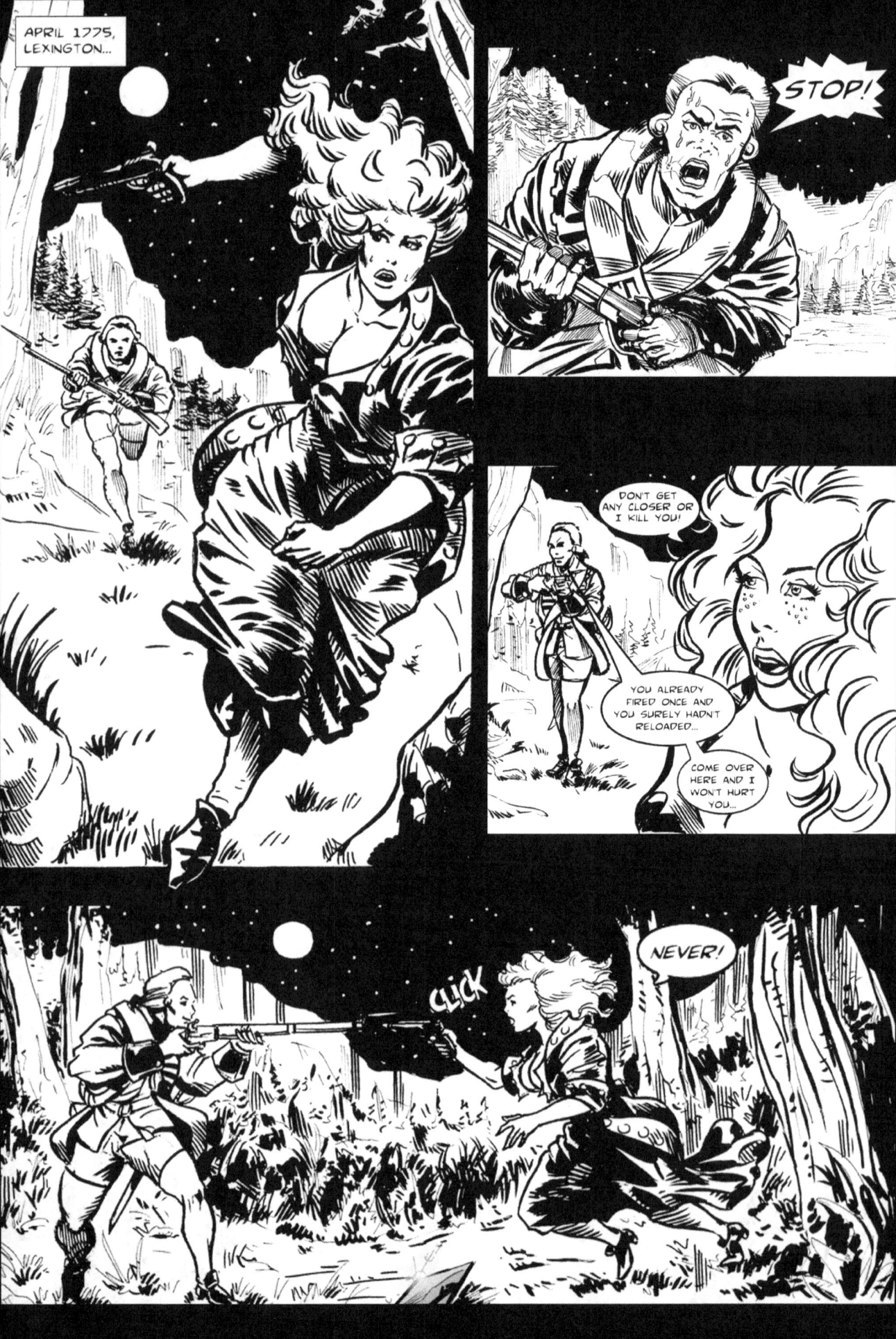

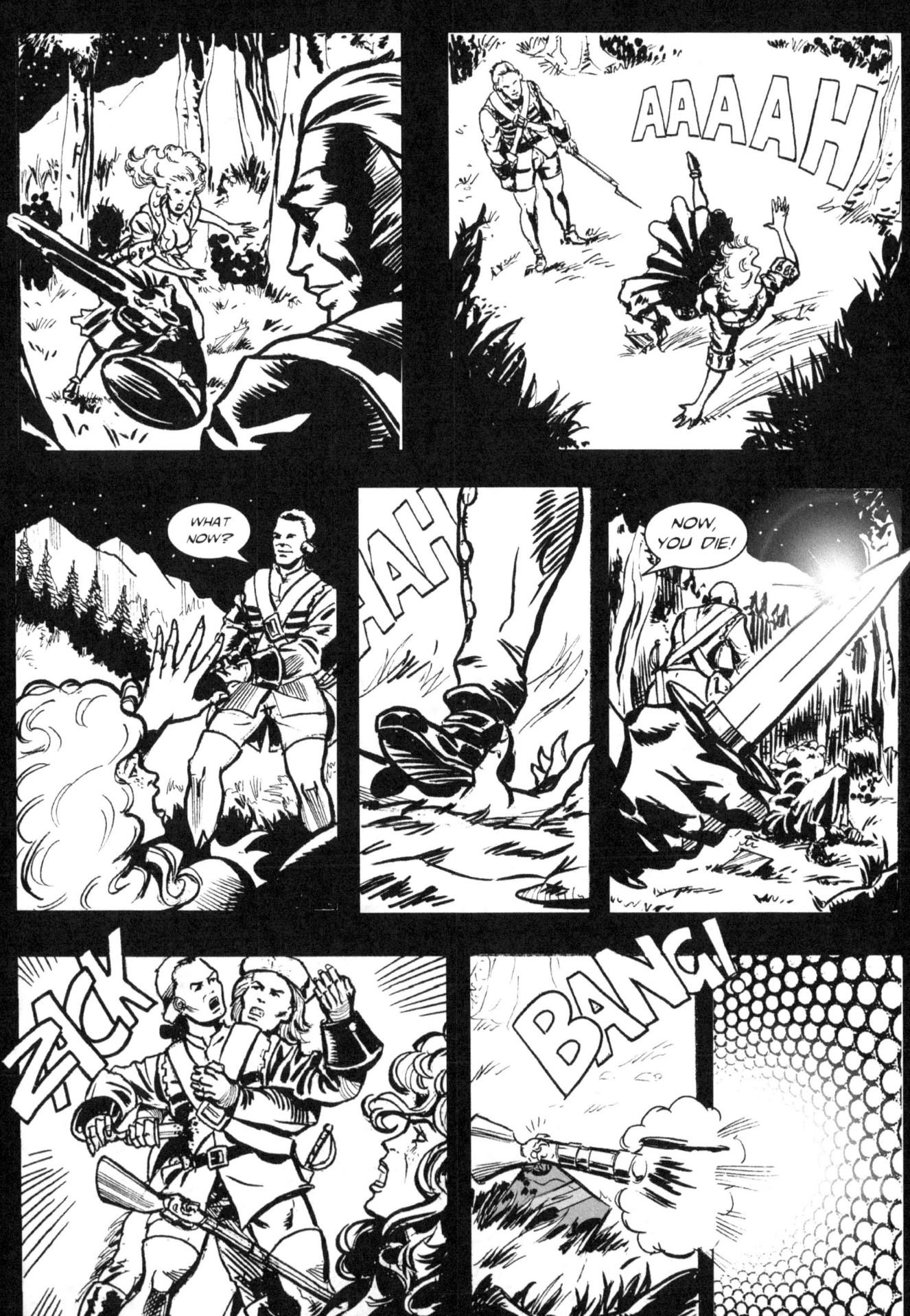

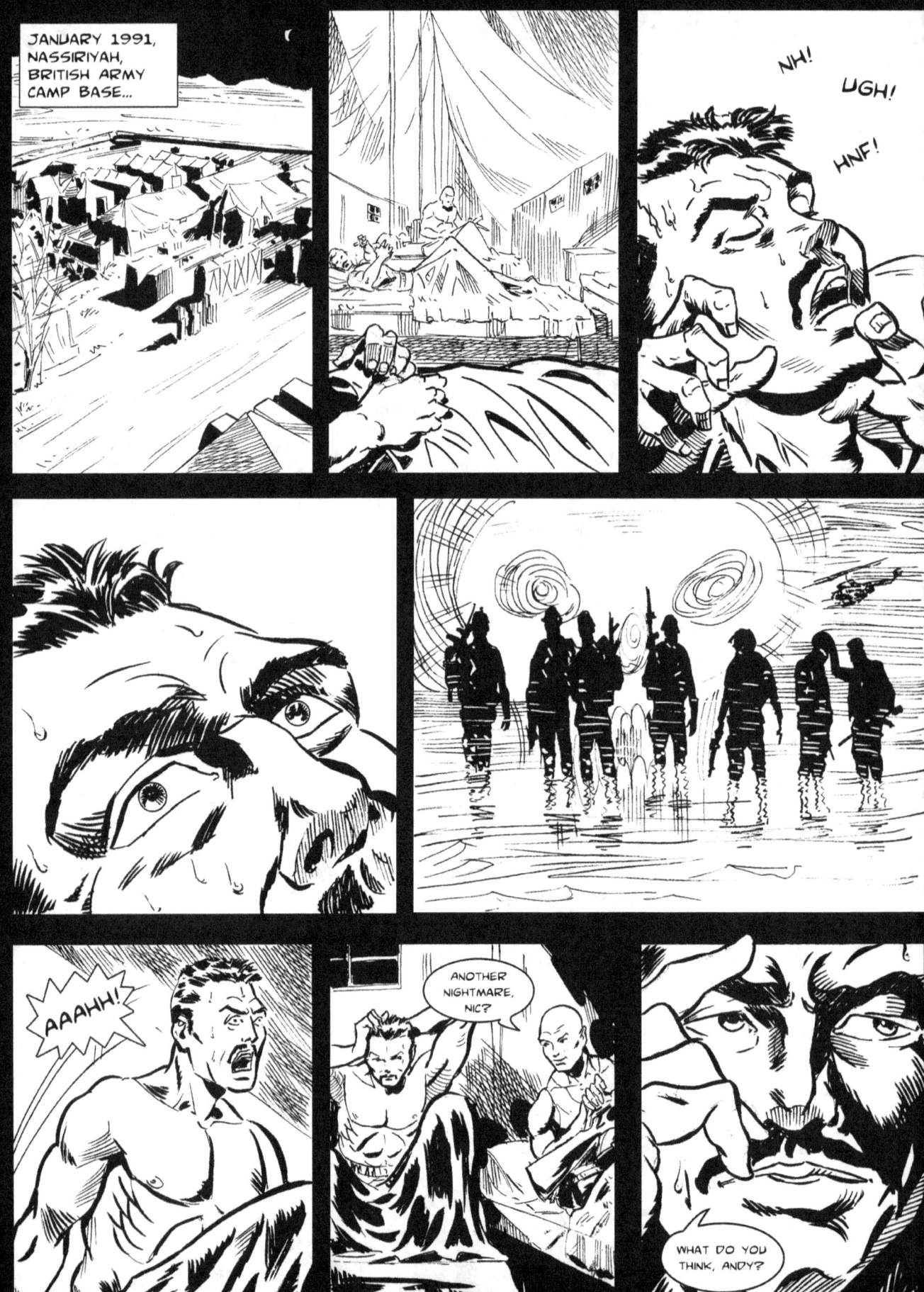

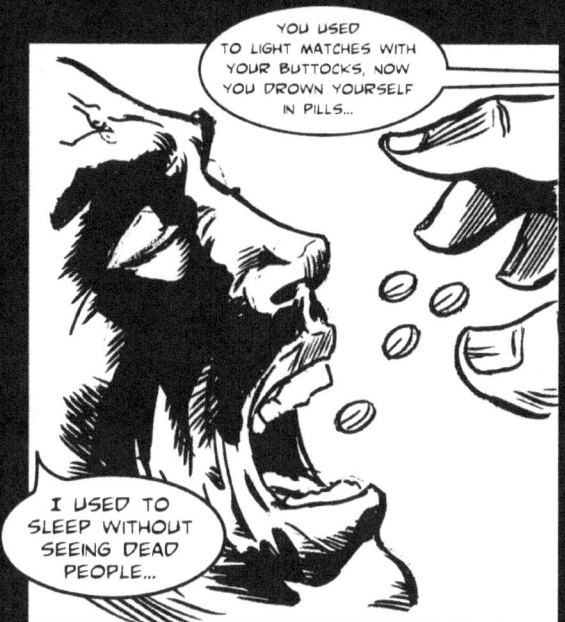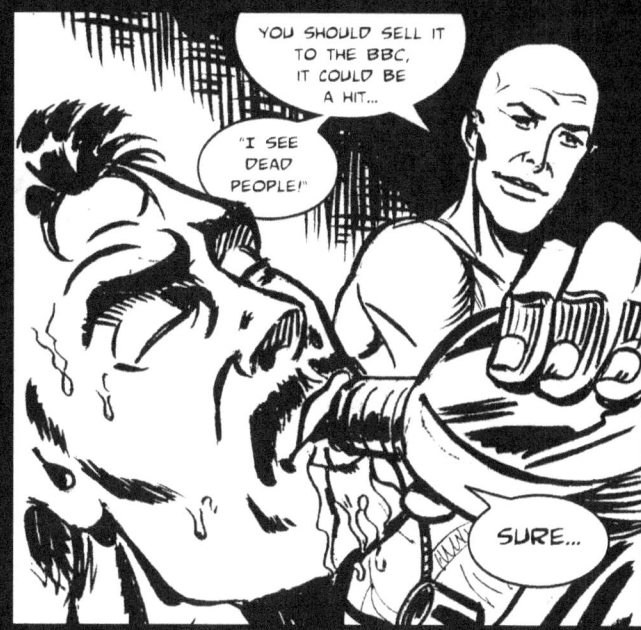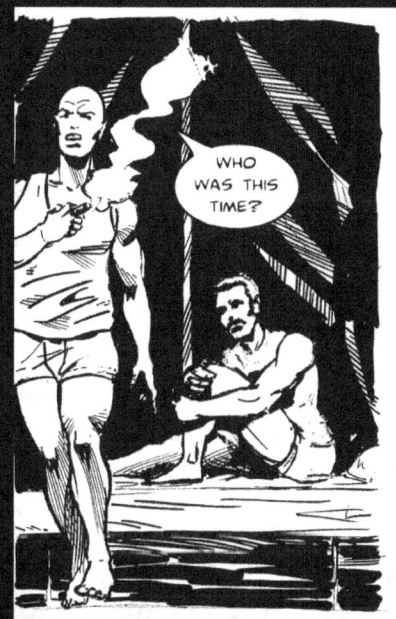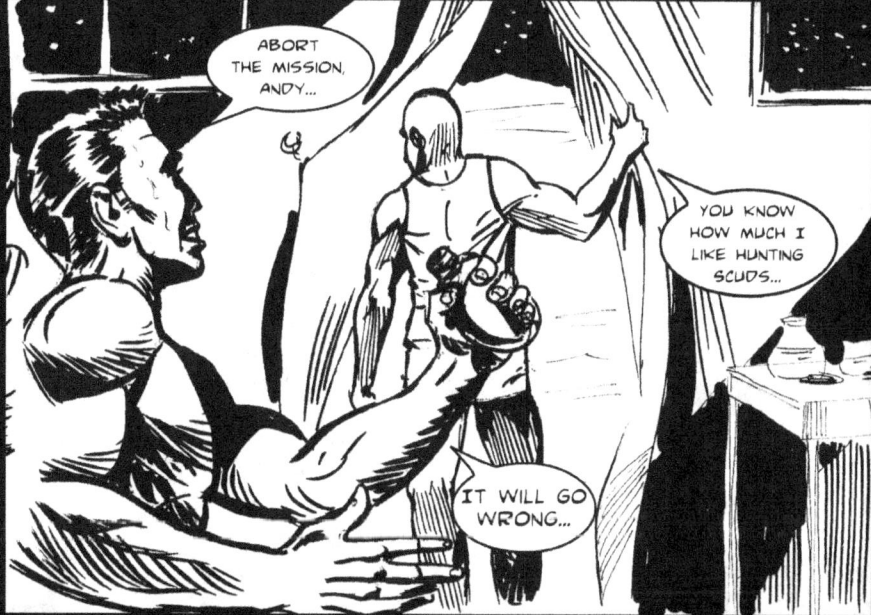

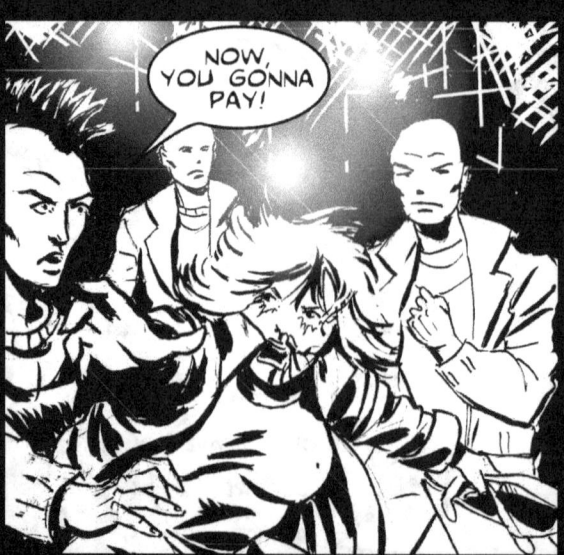

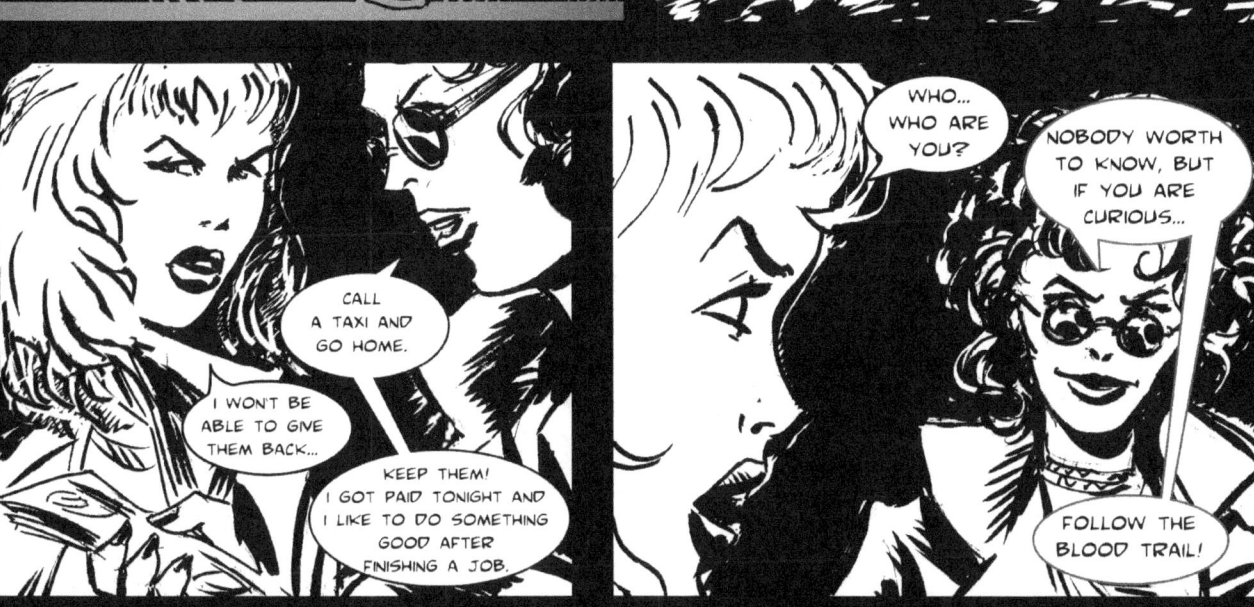

See you around...

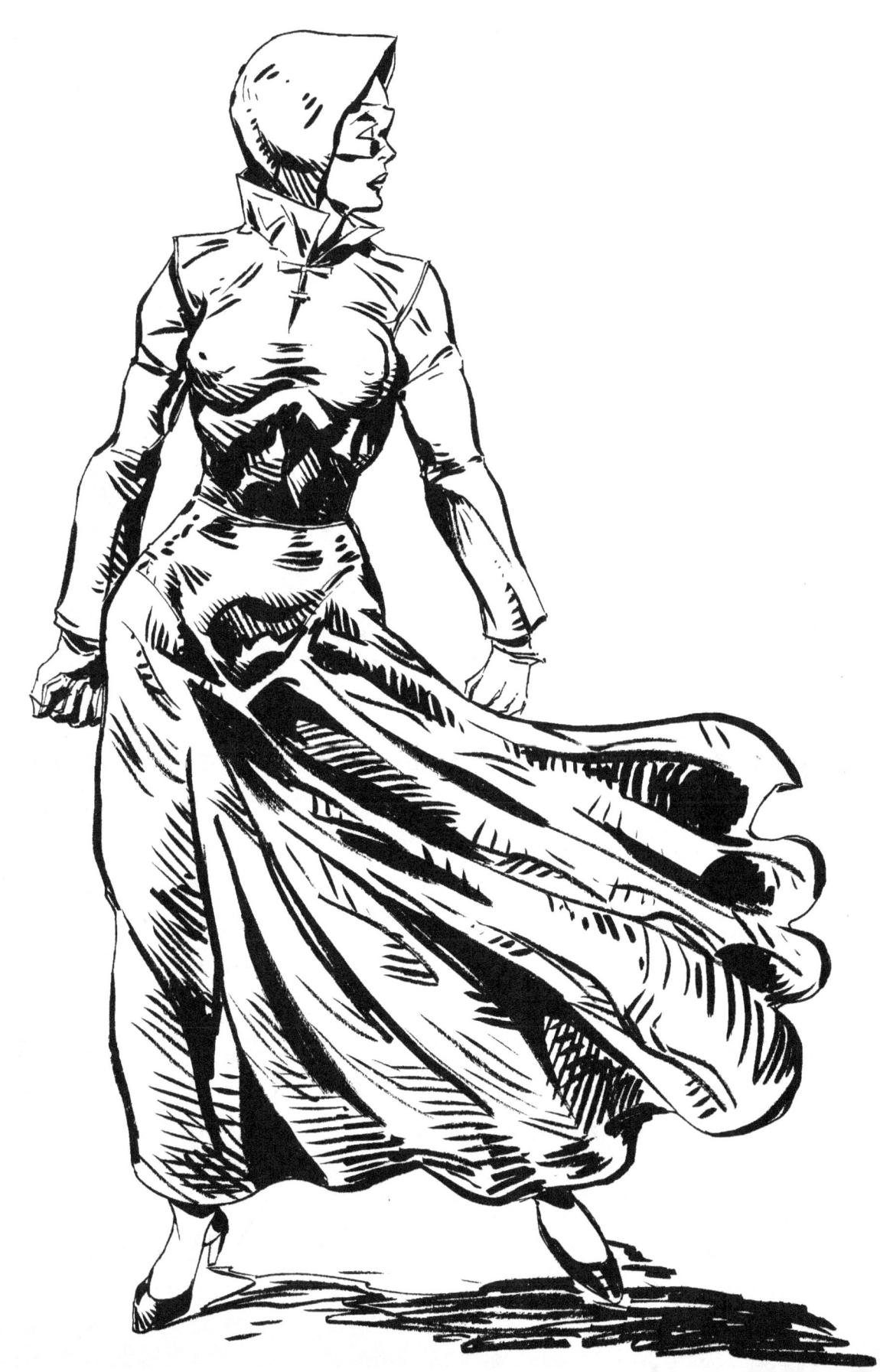

About Blue Monkey Studio

Blue Monkey Studio (BMS for short), is an Italian firm with writing, illustration and graphic design expertise.
It operates at international level in 3 complementary sectors: entertainment and cultural development, innovative new media technology for publishing, including mobile, and public/private financing strategies for education, culture and research in entertainment.
It also promotes the employability of creative minds with a special focus on young people who are interested in pursuing a career in the cultural and entertainment fields, delivering distant, traditional and on-the-job training.

We humbly believe in the necessity to steal ideas from the gods and bring them to Earth for the greater good of All!

www.ingramcontent.com/pod-product-compliance
Lightning Source LLC
Chambersburg PA
CBHW080952170526
45158CB00008B/2448